Ghost Stories and Legends of Eastern Connecticut

Ghost Stories and Legends of Eastern Connecticut

Lore, Mysteries and Secrets Revealed

Donna Kent

Published by Haunted America
A Division of The History Press
Charleston, SC 29403
www.historypress.net

Copyright © 2007 by Donna Kent
All rights reserved

Cover image: Artist rendering by Mashall Hudson of the *Charles W. Morgan*.
All photos courtesy of the author.

First published 2007

Manufactured in the United Kingdom

ISBN 978.1.59629.317.5

Library of Congress Cataloging-in-Publication Data

Kent, Donna.
Ghost stories & legends of eastern Connecticut : new secrets of old lore revealed / Donna
Kent.
p. cm.
ISBN-13: 978-1-59629-317-5 (alk. paper)
1. Ghosts--Connecticut. 2. Haunted places--Connecticut. I. Title. II. Title: Ghost stories and
legends of eastern Connecticut.
BF1472.U6K46 2007
133.109746--dc22
 2007029681

Notice: The information in this book is true and complete to the best of our knowledge. It is offered without guarantee on the part of the author or The History Press. The author and The History Press disclaim all liability in connection with the use of this book.

All rights reserved. No part of this book may be reproduced or transmitted in any form whatsoever without prior written permission from the publisher except in the case of brief quotations embodied in critical articles and reviews.

This book is dedicated to my soul mate and the love of my life, Brian Jones, and to my two wonderful children, Chloe and Justin.

Contents

Acknowledgements 9
Introduction 11

The Deadly Grounds of Old Trinity Church, Brooklyn 13
Israel Putnam's Gravesite and the Mortlake Manor, Brooklyn 25
The *Charles W. Morgan* and the Buckingham House, Mystic Seaport 35
The Whitehall Mansion, Mystic 49
Elizabeth Shaw and the Windham Inn, Windham 61
The White Horse Inn at Vernon Stiles Restaurant, Thompson 67
The Bloody Orchard, Franklin 77
The Lighthouse Inn, New London 85
Eugene O'Neill's Monte Cristo Cottage, New London 103
Route 138—A Cruise Down the Vampire Highway, Jewett City 113
Harvest Restaurant, Pomfret 119

About the Author 125
Endnotes 127

Acknowledgements

I would like to thank all the members of the Cosmic Society of Paranormal Investigation for their endless encouragement and contributions in the writing of this book. Especially: Rich and Cardy Keegan, Mark Larsen, Margaret Scholz, Matt and Chris Nickerl, Leanne and A.J. Root, Brendan and Charlene Logan, Chadi Noujaim and Nicole Donzello and Jenna Santorelli. I owe more than words to Brian Jones for countless hours of writing and editing with me and to my children Chloe and Justin for

Acknowledgements

bearing with me (or without me as the case may have been) while I was immersed in completing this publication. Thanks also go to my best friend, Michele Polvay, who made sure we stayed fed throughout.

Special thanks also to Faye Ringel, PhD, professor of English and Humanities at the U.S. Coast Guard Academy; Dale Plummer, town historian, Norwich, Connecticut; Patricia Sweeney, librarian of Derby Neck Library; Ann Tate, librarian of the Stonington Historical Society; Bev York of the Windham Textile and History Museum; Bob Falcone and Adam Lippman for their photo help.

The stories within wouldn't have been told without the help of Betty Cordellos of Haunted Connecticut Tours, the owners and docents of all of the haunted locations included herein and the voices of the spirits themselves, who definitely made themselves heard and guided my hand to information in order to get their respective stories straight, most times around 2:00 a.m.

Introduction

The accounts contained within this book for the most part occurred in what are now public places. These accounts discuss both the legend and the investigations conducted by my group, the Cosmic Society of Paranormal Investigation. The Cosmic Society's aim is to uncover evidence that supports the accuracy of the legends and to ascertain the identity of the spirit (or spirits) that haunt a given location. In some cases we are successful in both of our missions, while in others questions remain unanswered.

Paranormal and psychic investigation is still a developing field. Please keep in mind that this is not a "how-to" manual, although you will certainly learn a lot about paranormal investigation just by reading the stories. This book only paints part of the investigative picture. If you are a skeptic and only believe in scientific explanations, I remind you that science once maintained that the world was flat. Science has not yet disproved the paranormal. In fact, I've seen scientists reach so implausibly far to find a scientific explanation for an unusual event that it requires more faith to believe in that explanation than a paranormal one! However, scientific examination remains a critical part of the paranormal investigator's toolkit because it helps to rule out a potential natural cause for phenomena.

A critical aspect of paranormal investigation is the investigator's mindset. It is important to remain objective and to prevent the desire for a particular outcome from affecting the conclusions of a case. Being overly eager or overly skeptical can equally skew a set of conclusions. The best way to approach an unusual event is to keep an open mind, look for natural causes first and eliminate them one by one until a natural explanation is found or until all natural possibilities have been ruled out. It is also important to remember that even in cases where natural explanations have been excluded as causes, possible explanations do not necessarily indicate

Introduction

the paranormal. The paranormal is identifiable through specific activity and particular patterns recognizable as such. Sometimes cases are simply inconclusive. The only way to successfully identify paranormal patterns is to study with an experienced paranormal investigator and to continue learning through constant and evolving experience. A paranormal investigator must also learn the signs and patterns that reveal a possible negative case and know how to keep herself shielded from harm.

Orbs can look like reflections, dust particles, or moisture and rain. Orbs are very common in photos, and they can certainly indicate spirit energy. However, because they are so common and because they can be explained very easily by normal physical phenomena, the paranormal investigator has moved beyond orbs and looks for more tangible evidence. It is crucial to examine other corroborating evidence, beyond the presence of orbs, before determining whether a location is haunted.

Now, sit back and enjoy the adventures and legends within!

The Deadly Grounds of Old Trinity Church, Brooklyn

Tucked away in a small hamlet of Connecticut sits an area of land known as the "Quiet Corner," Brooklyn. It is a community of Yankee quaintness and charm, perfectly groomed town greens and impeccable antique shops that suit its residents just fine. They prefer the tranquil, storybook life of attending their children's soccer games on Saturday afternoons and church services on Sunday mornings. Serenity reigned in the area until January 1982 when the calm was shattered by the grisly discovery of a young local girl's body behind the Old Trinity Church.

Tammy Williams was brutally murdered, and a man named Michael Ross concurrently entered and devastated the happy lives of Brooklyn's inhabitants. That name would mark the beginning of a nightmare from which some would never fully awaken.

Ross was an Ivy League college graduate (with a reported IQ of 122) and sexual sadist who stalked, raped, tortured and murdered at least eight woman and teens in both the "Quiet Corner" and New York. He trapped, brutalized, raped and killed at least six regional women, many of them teenagers. Two were only fourteen years old and were killed simultaneously. The body of Tammy Williams, seventeen, of Brooklyn was found in the pond to the left and behind the property of the Old Trinity Church. While walking home from her boyfriend's house on January 5, 1982, she was abducted by Ross, raped, strangled and dumped on the Old Trinity Church grounds. In her blood, on the right side of the church structure, he smeared the words "I love little girls."

The year 2002 marked the twentieth anniversary of serial killer Michael Ross's arrest. He was executed by lethal injection on Friday, May 13, 2005—Connecticut's first execution in forty-five years. A toxic cocktail of three poisons caused Ross to gasp for air, shudder and fall silent.

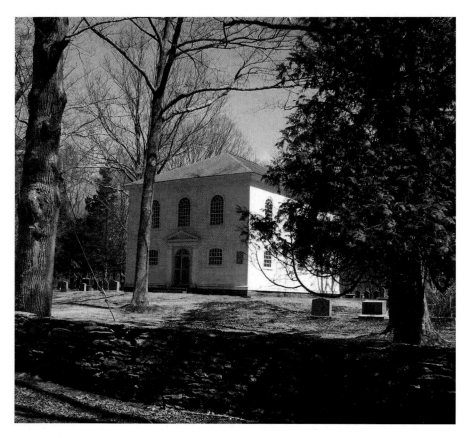

Old Trinity Church.

For the families of Ross's victims, his execution marked a bittersweet closure.

In one of his vicious acts, Ross desecrated a piece of what was once holy soil in the "Quiet Corner"; a place that screams from beyond this world to the psychically gifted. The Old Trinity Church and Burial Ground, located on Church Street in Brooklyn, grew out of interdenominational rivalry and love of money–not necessarily for the love of God. For those attuned to the paranormal realm, the area incites such horror, shock and dread that many claim to have the wind literally knocked out of them when visiting the site. It might be said that the negative foundation of the church set the stage and tone for Ross's future sadistic act.

Many tragic events surrounded the founders of Trinity Church in Brooklyn. In order to fully understand this plot of sour ground, we must first travel back in time over two hundred years to Newport, Rhode Island, and

The Deadly Grounds of Old Trinity Church, Brooklyn

A close-up of one of the gravestones.

enter through the heavy wooden doors of the Trinity Episcopal Church. There, in the front row pew we find Godfrey Malbone, one of Newport's wealthiest men and a devout churchgoer. In February 1734 the church's new organ arrived in Newport, carried on a ship owned by Malbone. It was long rumored to have been played and approved by Handel himself. Interestingly, if we were to look for Godfrey Malbone's remains we would still find them in the Trinity Episcopal Church for he lies buried right beneath the very pew on which he sat during Sunday worship services. His misfortunes in Newport will lead us back to Brooklyn, Connecticut, and to the Old Trinity Church there.

Godfrey Malbone Sr. may have been in a state of God's grace on Sundays in church, but he otherwise had a dubious reputation as what was then called a "Guinea trader" in the lucrative rumrunning business. He bought and sold slaves in exchange for goods—mainly rum or molasses (which was made into rum). He also traded in anything else that brought him money: pottery, porcelain, coal and precious metals. His routes ran between Newport, the American southern colonies, Boston, Europe and the West Indies.

Perilous conditions on the high seas constantly threatened the crews. They quickly learned to expect hard and grueling voyages aboard ships contaminated by diseases such as malaria and yellow fever. Pirates posed a

constant threat as they harassed and robbed the vessels. Many of Malbone's captains went down with their ships. Between 1727 and 1745 scores of Malbone's ships, crews and cargoes met with disaster and loss of life. One schooner was struck by lightning and completely obliterated. The ocean swallowed entire cargoes of gold, elephant tusks and other goods. Many ships were captured by enemies. Misfortunes piled up, and Malbone began to crack under the pressure.

Often before sailing, mystics cast astrological horoscopes for vessels to help predict trip conditions and establish the most favorable days for travel. In one instance, the mystic's prediction led to many deaths. Following the astrological forecast, captains of two of Malbone's brand-new privateer ships overloaded with cargo and over four hundred men set sail on the predetermined date—Christmas Eve 1745—despite the violently raging nor'easter that had descended upon the shore. Unfortunately, the storm grew into a ferocious hurricane. None of the ships or crews was ever seen or heard from again. It was said that over two hundred families in Newport were affected by the tragedy.

In 1742 Malbone built his own country mansion, Malbone Estate, and emblazoned the words "See What Money Can Do" over its front entrance. The gardens on the estate enjoyed the prestige of being among North America's foremost and finest throughout the eighteenth and nineteenth centuries. The crafty merchant hosted sumptuous feasts at his summer home—just before new voyages were charted—and waited until his fellow seamen were drunk on rum. He then persuaded the pliable sailors to sign on for perilous journeys.

On one occasion, just as dinner was being served, disaster struck. Malbone's elaborate estate caught fire and burned to the ground. Although he was deeply affected by the tragedy, he certainly wasn't about to lose face in front of his guests. He ordered his servants to risk life and limb by hauling tables out of the burning building and demanded that they continue to wait on his guests. They retrieved cold wine from the basement just in time and poured it as the house blazed furiously behind them. Malbone is rumored to have said, "By God, if I have to lose my house, I shall not lose my dinner!" Some have even speculated that if it weren't for Mrs. Malbone's uppity attitude the house might have been saved. Allegedly, she was more concerned with the firemen soiling her oriental carpets than in dousing the fire itself. Earlier that same year, 1766, George Washington dined at the Malbone mansion, though undoubtedly under much less dramatic circumstances.

In 1740 the land in Mortlake, Connecticut, (once part of Pomfret and now called Brooklyn) was owned mostly by Godfrey Malbone Sr. (the northern portion) and Israel Putnam (the southern portion). This land was

The Deadly Grounds of Old Trinity Church, Brooklyn

Gravestones in the church's burial grounds.

given to Godfrey Malbone's son, Godfrey Malbone Jr., in 1764.

Not only was Junior a chip off the old block—as aggressive, determined and forceful as his old man—but he was also in league with his father as a partner in the rumrunning and slave trade businesses. They acquired their wealth mainly through the trafficking of human beings.

Malbone Jr. owned a large three-thousand-acre plantation in Pomfret, Connecticut. He had two dozen slaves and was arguably the largest slave owner in Connecticut's history. In historical papers, his inventory list of "living creatures" was recorded as 80 cows, 45 oxen, 30 steers, 59 young cattle, 6 horses, 600 sheep, 180 goats, 150 hogs and 27 Negroes, precisely in that order.

Colonel Godfrey Malbone Jr., like his loyalist father before him, was a Tory and a servant to the Lord. He refused, however, to be loyal to or in any way serve his rival, the American patriot and Revolutionary War hero Israel Putnam. Putnam held title to just as much property as Malbone and decided to build a new Congregational Church with the intent that it would also serve the community as a meetinghouse. This would cost the younger Malbone a small fortune in taxes, and he became outraged. Putnam and Malbone sat on opposite sides of both the political and religious spectrums, and there would be no meeting of minds either in church or without.

Prior to Putnam's construction plans, Malbone supported the existing church and paid large sums in taxes without any objection. In angry retaliation, Malbone countered Putnam's Congregational Church by building a Church of England, throwing more fuel onto the fire. He enlisted the help of nineteen heads of families and obtained their signatures. They declared that their financial support of the new Church of England exempted them from paying taxes on the Congregational Church.

Malbone's church construction went forward in Brooklyn, and by April 1, 1771, the building was ready for use. The interior design was modeled after Trinity Episcopal Church in Rhode Island, where his father is buried.

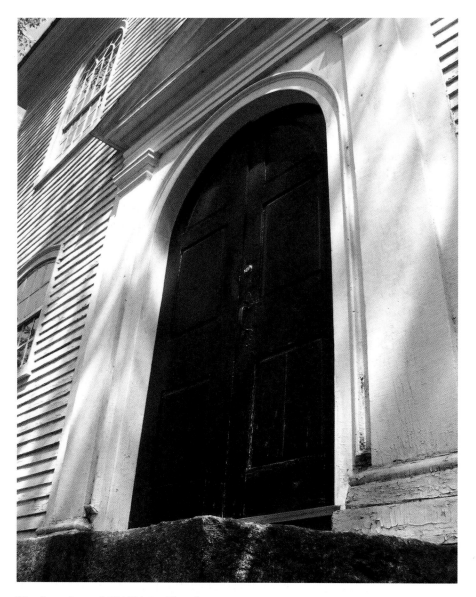

The front door of Old Trinity Church.

The Deadly Grounds of Old Trinity Church, Brooklyn

It was aptly named Trinity Church, now called Old Trinity Church. An anomaly for a place of worship, the church had no steeple and looked like a common meetinghouse. However, the building served strictly as a church as the Episcopalians were firmly nonsecular at the time. Named by Malbone himself, Trinity Church was dedicated on April 12, 1771. This was an important historical event as it was the first formal dedication service performed in Windham County. The building is the oldest Episcopal Church still standing in what is the oldest diocese in the United States. The burial grounds hold the remains of long-dead priests who served the church through the trials and tribulations of the times.

In a serene and beautiful area, the church is a gable ended, beige, clapboard structure, minus a steeple, with faded or peeling paint in many areas. It is by no means in a state of disrepair—the faded paint actually lends to its historical character. One is immediately struck by the number and placement of the graves around the church—they almost completely surround it except for in the front of the building. A small, low, wrought iron gate creaks open into the front of the grounds, and the entire site is surrounded by well-maintained stone walls. Although the site invites curiosity, the stone walls and a sign marked "Private Property" give one pause, as if someone (or something) is trying to conceal the dark happenings within.

In the front center of the church is an arched double door, painted black, which is a striking offset to the beige paint on the overall structure. There are three arched windows on the second story and two more on either side of the door on the first story. When facing the front of the church, one might walk around to the right side and find the spot where Michael Ross painted his words in blood on the wall. Though the area has been re-painted, if you look closely in the right light, you can almost see the spot between the second and third windows towards the back. Graves of Israel Putnam's relatives are located on that same side. There are two intriguing sarcophagus graves in that area as well. Six more of the same can be found behind the church.

Around the left side, and downhill from the rear corner, a path leads to the pond where Tammy Williams's body was discovered. Bracken and algae cover the deathly still water of the pond, which is surrounded by skunkweed, and abundant insect life buzzes around the edges. The pond is very small—not much bigger than the average backyard swimming pool—and it looks as if one could simply wade across it rather than swim. The stone wall from the church extends down and across to the far end of the pond. It is difficult to conceive how such a dark and evil act could occur in such a sacred place. But the turmoil that surrounded the original founding of the church is rooted in its foundation, operating in the structure itself and in its natural staging. While the surrounding landscape exudes a tranquil, old colonial

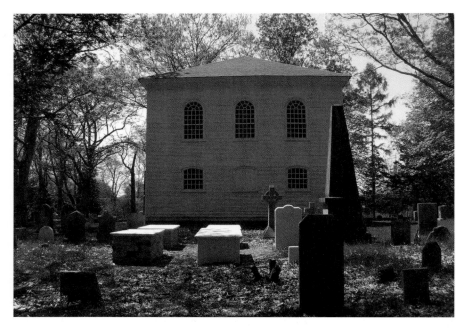

Behind the Old Trinity Church. Note the sarcophagus graves.

essence, the Old Trinity Church property is more sinister in its beauty.

After the Revolutionary War began, worship in the Episcopal Church became increasingly unpopular. Trinity Church closed, and its congregation diminished, except for a few remaining loyalists. With the death of Colonel Godfrey Malbone Jr. on November 12, 1785, the church lost its chief patron and devotee. The Anglican Missionary Society also withdrew its aid. The outlook for the building was dismal.

Interestingly, despite the rivalry of Malbone and Putnam, a colonial twist on Romeo and Juliet took place. Colonel Daniel Putnam, son of Israel, married Malbone's niece, Catherine Hutchinson, on June 9, 1791. Perhaps their union broke the rivalry of Israel and Godfrey's remaining family once and for all.

Trinity Church, after a long period of irregular service, was resurrected in 1828. The building was repaired and remodeled in 1835, self-financed by the parish and many families that joined the congregation. Both the turmoil surrounding the Malbones and the conflict of the Revolution could certainly help to explain the various paranormal activities reported at the site.

In the present century, several eyewitness sightings of spirits and apparitions at the churchyard have been reported. On at least three separate occasions people reported seeing a young woman, apparently in a state of

The Deadly Grounds of Old Trinity Church, Brooklyn

shock, walking along the inner edge of the churchyard. She never interacted with the observers, who invariably walked towards the woman to speak with or attempt to console her. She simply vanished.

We met on a hot summer day in the middle of a heat wave in 2001. Betty Cordellos, owner of Haunted Connecticut Tours, Michelle Glaston, the tourism director, and I were in a lighthearted mood in spite of the heat, which made us somewhat lethargic. The quiet stillness of the grounds was overwhelming and felt to me somehow unnatural.

My first experiences here were highly disturbing and my lighthearted mood soon dissipated. I had a strong desire to walk around the left of the church to the far stone wall that separates the cemetery from a neighboring residential home. I was standing with the wall to my left and facing the rear of the cemetery. The church was to my right with a small expanse of grass and gravestones in between. Suddenly, invisible hands with an incredibly strong grip grabbed hold of both of my wrists. These "hands" twisted my arms back and forth while tightening their grip even more. Fingernails dug into the undersides of my wrists, leaving marks. I was literally jerked forward, my arms outstretched, towards the back of the graveyard. I experienced feelings of terror as the event unfolded—what I now believe to be the residual energy on the location of Michael Ross's victim, Tammy Williams. At the time, I had never heard of Michael Ross or his connection to the location.

Still feeling sick to my stomach, I tried to relax and "go with the flow" as I was pulled farther into the woods, behind the gravesites and down a footpath leading to a small body of water. The pain in my wrists was more than uncomfortable, although the marks from earlier had now faded. Something compelled me to go farther into the thicket, but I soon began to resist the urge to continue. I was beginning to feel faint and, coupled with the intense heat, my knees gave way and I fell to the ground.

My two companions rushed over to my side, and I told them about my experience. It was then that Michelle told me the story of Michael Ross, and she was amazed at what happened to me. I was pulled to the exact spot where he committed his crime. She informed me that "one of his victims had been discovered, strangled and floating, dead in the water, just down that old path…" Back in the car, I began to feel normal again, except for the heat.

Local legends have attempted to explain the paranormal activity at the Old Trinity Church, including the consequences of serial killer Michael Ross's actions. There have long been rumors of occult activity and satanic rituals

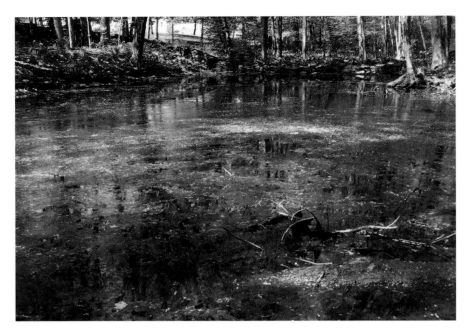

The pond where Tammy Williams's body was found.

in the catacombs under the church. In a recent interview I questioned two young men who happened to attend my Lantern Light walk during my Haunted Connecticut Tour. They told me they had been "trying spirit photography at the Old Trinity Church location for about two years" and that it was "one of the most eerie places they had ever visited. Whatever one experiences in the daytime here is not comparable to the feeling of evil present here at night. The place seems alive."

Many claim that the church was a stop on the Underground Railroad (a common theme in this part of Connecticut), but that many slaves had perished in the basement while waiting to flee. I wonder how many of the souls of slaves sold or traded by Malbone Sr. had their otherworldly hands in some of the paranormal events that went on during his lifetime.

The area, land and property look very dark. This is notable since the location of churches, shrines, temples, mosques, synagogues and other places of divine worship are usually chosen for their abundance of positive, bright energy. The Old Trinity Church and Burial Grounds emanate negative vibes.

Michael Ross's history of mental illness—including hearing voices, having uncontrollable urges to kill and rape and suffering from multiple personalities—can all be indicative of demonic possession. He demonstrated a feat of superhuman strength—another trait of a possessed individual—

The Deadly Grounds of Old Trinity Church, Brooklyn

when he overpowered and murdered two girls together.

In 1970, 201 years after its construction, the Old Trinity Church was placed on the National List of Historic Places.

Although the church now stands silent on Sundays—and almost every other day of the year—there is one exception. On All Saints Day, November 1, the original Bible, Book of Common Prayer, Communion pewter and antique alter linens are used ceremonially.

I implore you to be very wary if you decide to visit Old Trinity Church in Brooklyn, Connecticut, and venture onto its dark and conflicted grounds.

Israel Putnam's Gravesite and the Mortlake Manor, Brooklyn

Israel Putnam was born on January 7, 1718, in Salem Village, Massachusetts, to Joseph and Elizabeth Putnam. He was the tenth of eleven children. Joseph spoke out against the village's infamous witchcraft frenzy. Israel's own relative, Anna Putnam, was one of the accusers. Fighting spirit was inherent in the Putnam family and Israel's father kept horses at the ready and fully loaded pistols on hand in case the village tried to indict him on charges of witchcraft. Nobody ever dared.

Israel worked on his family farm and fruit tree orchard raising herds of sheep, goats and oxen. He was happily married to Hannah Pope in 1739, who also hailed from Salem, Massachusetts. They had a son, Daniel, and within the year moved to the wilds of Mortlake (now Brooklyn), Connecticut, where Putnam became a major landowner.

He was the embodiment of good character, bravery and spirit. Israel didn't have any formal education but was known for his courage, being one of the very first to volunteer when news of the French and Indian War broke out.

It was August 8, 1758, and Putnam, commander of Connecticut forces, led over 530 of his Roger's Rangers from the front, through forests and thickets, unaware that he was marching them straight into a Native American trap. He was dispatched to end Pontiac's siege of Detroit but met the ambush in New York. The chief of the Caughnawaga and Putnam engaged in hand-to-hand combat amidst the yells and war cries of the Native Americans. Putnam's gun misfired while pointed at the Caughnawaga leader's chest and the chief, with hatchet raised, captured him and quickly tied him to a tree.

At this point in the battle, Putnam was positioned dead center of the fighting. Arrows and bullets pierced his clothing and, being so tightly fastened to the tree, he was unable to move. One Caughnawaga warrior

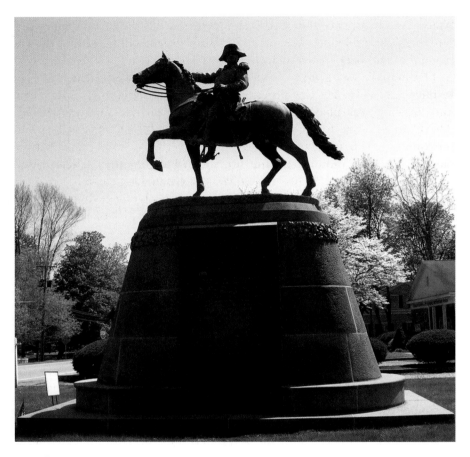

Israel Putnam's Memorial.

delighted in flinging his tomahawk at Putnam's head over and over again, narrowly missing each time. Not to be outdone, a French soldier then tried to shoot Putnam, but when his weapon misfired, he settled for beating Israel mercilessly with the blunt end of his musket. Putnam repeatedly cried out that he was a prisoner of war, but to no avail. None of his enemies understood the English language. The skirmish raged on for about two hours, and Putnam was faring poorly in the hands of the enemy. Stripped of his clothing, wrists bound so tightly that they swelled, exhausted and bloody, the Native Americans loaded upon him the weight of many fallen soldier's packs. He was then forced to walk for miles carrying this burden. Israel, unable to endure any more brutalities, implored that they execute him as quickly as possible. At that instant, a French officer came to Putnam's aid and ordered that he be untied and that some of the weight be removed. One

Israel Putnam's Gravesite and the Mortlake Manor, Brooklyn

Native American gave him a pair of moccasins, but the torture continued into the night, and for the rest of his life Israel bore a scar from a tomahawk blade that had been savagely thrown at his left cheek.

The outlook was grim for Putnam and the Native Americans decided to burn him alive. He was fastened to yet another tree, deep in a forest, and kindling was placed around the base of the tree and set on fire. The Caughnawaga formed a circle around the tree, dancing, yelling and screaming their battle cries. God's hand intervened as a brief rain shower passed overhead, diminishing the fire somewhat, but the Caughnawaga quickly rekindled it, and Putnam resolved that his time on earth was rushing towards its end. It was by the grace of another French officer that Israel was saved as he rushed in and cut Putnam loose just in the nick of time. Fearing for his own safety, he escaped with Putnam until he could be delivered back to his own troops.

Timing was on his side in the French and Indian War, but it was reported that General George Washington, of the Continental Army, was forced by Congress to hold Putnam responsible for fatalities in Long Island for his failure to win the battle. In fact, a court of inquiry was formed to investigate Putnam's competency, but he was fully exonerated. Even so, in 1779, during the American Revolution, he was relegated to the title of "Chief of Recruiting," losing his battlefield command. Regardless of reprimands, legend states that Israel was so devoted to his new position of major general that upon hearing the news of British troops fighting the locals in Boston, Israel literally dropped everything, leaving his son Daniel to unyoke the oxen in his fields in Brooklyn (now the green). He was eager to lead his militia. Amazingly, he arrived via horseback in Boston just eighteen hours later and played a most prominent role in the Battle of Bunker Hill. It was during this battle that Putnam uttered his famous line: "Don't shoot until you see the whites of their eyes!"

Israel was also famous for his bravery when he killed a female wolf that was attacking livestock in the area. The she-wolf herself was infamous and had been pursued by Putnam and his clan after a night of slaughter in which at least seventy-five goats and sheep were killed and other animals were wounded. As the legend goes, footprints of the three-toed creature were seen in the light snow that fell. Following these, bloodhounds soon tracked the animal into a small crevice of rocks. The band of farmers tried everything to snuff her out—sending in dogs, burning straw, etc.—but to no avail. They could not smoke the wolf from her hole. The hounds, after being wounded by the smoke and sulfur fires, refused to return anywhere near the cave. Nothing seemed to work and the wolf tenaciously held her position from below ground. Putnam ordered one of his slaves to enter

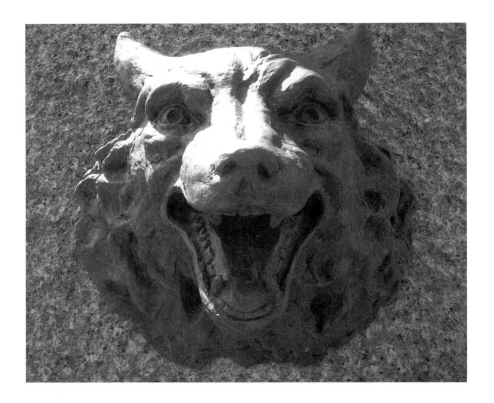

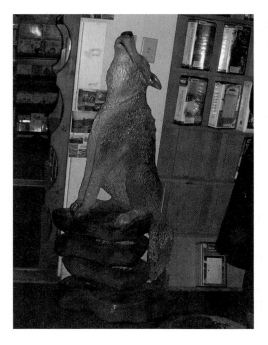

Above: One of the two wolf heads on the Putnam monument. These have been replaced at least once due to thieves.

Left: The statue of the she-wolf.

the cavern and shoot the wolf, but he, like the dogs before him, refused to comply. Furiously disappointed, Putnam muttered something about how ashamed he was to have a coward in the family and decided he would be the man for the mission, despite protests from the other farmers.

Determined, Israel shed his coats, tethered a rope around his legs and proceeded headfirst into the opening of the cave. With his musket at his side and a torch made of birch limb, he confronted the wolf at the farthest end of the cavern, which was no more than three feet wide in any section. On hands and knees, Israel faced the snarling wolf, got nervous and signaled for his companions to pull him out. His colleagues yanked him from the hole with so much force that his shirt ripped and came up over his head, and he sustained serious cuts and bruises to his head and body. He composed himself briefly and then, undaunted, entered the cave a second time, his musket loaded with buckshot. The wolf, perhaps aware of her imminent death, did all she could to protect herself. Snarling, growling and gnashing her sharp teeth, she readied herself to lunge at her enemy. But she was outmatched: her foe was General Putnam who had survived war and torture by Native Americans. With one swift shot he killed the beast. He was again removed from the fissure—more carefully this time. After revitalizing himself with fresh air, he descended a third time into the cavern to make sure the job was finished. Once more he was dragged out, this time with the dead wolf in tow. Israel, and the rest of the farmers, slept soundly that night.

The Abington Social Library, established in 1793, commissioned a sculptor to create a wolf statue commemorating the story of Israel Putnam and the wolf. There were problems from the onset—the first two wooden statues burned in mysterious fires. Little did they know that when the third statue arrived they would experience even stranger events. On a warm, sunny day everyone in the library suddenly felt chills course down their spines, and all activity stopped as patrons and workers alike looked at each other in disbelief. They had heard the unmistakable sound of a wolf howling. It seemed to be coming from all directions at once. The next morning, imprinted in the fresh snow, were wolf tracks circling the library. One track was particularly distinct: it was a three-toed paw print. The actual den is still within hiking distance of the library in a section of the Mashamoquet Brook State Park.

Putnam's military career ended after he suffered a stroke during a battle and was forced into retirement. He was a devout member of his Congregational Church and experienced increasing faith and deepening spirituality in his later years. He returned to Brooklyn to live out his remaining days until his death on May 29, 1790, after a two-day illness.

According to provincials of the Mortlake area, past and present, Israel's apparition is "alive" and well—confused at times, but still in command.

Putnam has been commonly sighted at Mortlake Manor or Mortlake House. "Mort" is the Latin word for "death." This area of Mortlake is the namesake of a town in London where, in 1348, the bodies of thousands of people killed by the Black Death were tossed into lakes. The Reverend Josiah Whitney built the house in 1761 for his bride and lived there for sixty-one years. He was a close friend and confidant of Putnam. The manor functioned as a church meetinghouse during the reverend's tenure as the pastor of the Unitarian Church.

Edith Kermit Carrow, a blood relation to the Putnam family and wife of Theodore Roosevelt, ran the building as a country inn from the 1920s to the 1930s. From the late 1950s through the 1980s the building served as a rest home and boarding facility for the elderly. It was dismantled down to the frame in 1988 and a third story was added. Today, the building is known as Mortlake Commons and is home to the post office, a bank on the first level, offices on the second and the Northeast Connecticut Visitor's District and Tourism Department on the third.

Employees in the building regularly experience odd occurrences. I spoke with a woman from the bank who described strange power and electrical problems. Power providers were called in and reported no power surges or lapses in service, and electricians found no signs of faulty wiring or other technical reasons for the anomalies in service. This left the bank employees without an explanation as to why the bank's alarm was continually going off at all hours of the night and early morning. Of course the police had to respond each time, and it caused quite a commotion. The woman's boss had to be awakened as someone had to arrive to meet the police.

There were other strange incidents at the bank. In the middle of a busy day the radio changed stations by itself. Banking music is commonly set to a very low, easy-listening volume. On numerous occasions—and witnessed by all within earshot—Christmas music suddenly blared through the bank and offices at a deafening level. Shortly before or just after these outbreaks of song a clergyman's ghost was reported as being seen kneeling in prayer.

Israel's ghost is just as ambitious in death as the man was incarnate. The death of the hero was a huge affair, one that Putnam and Reverend Whitney still seem to relive in some sort of eternal loop. A uniformed soldier, fitting the description of Israel Putnam, has been seen striding through the building in the area where his body was laid during his wake, only to disappear into thin air upon investigation. This same figure has been spotted on horseback, with both the horse and rider disappearing when

Israel Putnam's Gravesite and the Mortlake Manor, Brooklyn

Mortlake Manor as it looks today.

flashlights or headlights illuminate them. An elderly woman's ghost has also been seen on the second floor of the building.

This was the place where Israel Putnam's funeral was held—one of Windham County's largest ceremonies of its kind ever conducted. Reverend Whitney presided over the services, with many of the general's Freemason friends and associates speaking on his behalf and conducting eulogies. Reverend Timothy Dwight, who went on to become president of Yale College, wrote the inscription on his tombstone. Putnam was interred in the Brooklyn cemetery. The brick grave was three feet high with a marble top. Unfortunately, the old slab was mercilessly vandalized and disfigured by relic hunters and has become illegible—a disgrace to the war hero's memory. The original marker can be viewed under glass in the Connecticut State Capitol in Hartford. Dwight's epitaph was transferred to a new bronze equestrian memorial statue of Israel Putnam which was unveiled with much celebration by Putnam's great-grandson on June 14, 1888.

Putnam's bones were moved to the ground under the new monument. The large bones were very much preserved, especially the hipbones, which a descendant used to identify them as Putnam's. There are two wolf heads attached to either end of the monument, which have had to be replaced at least once due to thievery.

> If a Patriot,
> remember the distinguished
> and
> gallant services
> rendered thy country
> by the Patriot who sleeps
> beneath this marble;
> if thou art honest, generous and worthy,
> render a cheerful tribute of respect
> to a man
> whose generosity was singular,
> whose honesty was proverbial;
> who raised himself
> to universal esteem and offices of
> eminent distinction
> by personal worth and a useful life.

The inscription on Israel Putnam's memorial.

The coffin itself was almost totally decayed but a piece of the burial shroud was found and with the remains of the bones and fragments of the casket, was placed in a metallic container approximately five feet long and reinterred. A large stone that had been cemented directly over the body in 1790 (and perhaps was what kept the bones in such good condition) was once again used in the same manner. Israel's bones may finally be locked in place but it seems poor Israel's soul just can't rest. One witness stated:

> *I was driving past the statue at about ten minutes to eleven on a Friday night. A greenish glowing fog caught my attention to the right and I*

Israel Putnam's Gravesite and the Mortlake Manor, Brooklyn

Israel Putnam.

slowed my car down for a closer look. I then discerned that the fog had taken the shape of a man, dressed in a military uniform consistent with Revolutionary times. The man was an exact double of the person astride the horse at the top of the statue, except that he was looking toward the ground and had taken a few steps toward the street. I pushed the pedal to the metal when I realized I had just seen Israel Putnam's ghost!

Located on Route 169, the statue is near the post office and across the street from the Brooklyn Library. It is also right next door to Mortlake Manor.

The historical society building is located behind the statue and houses many of Israel Putnam's relics and memorabilia. Doors have been known to open and close by themselves, and the uniformed soldier has been spotted disappearing through plastered walls.

If you visit Brooklyn and Israel Putnam's grave, don't run until you see the whites of his ghost eyes!

The *Charles W. Morgan* and the Buckingham House, Mystic Seaport

Have you ever noticed that most ghost stories begin with some version of "It was a dark and stormy night"? Maybe you've noticed that a lot of ghostly sightings or occurrences happen during thunder and lightning storms? The truth is that ghosts and spirits use these conditions to better manifest and become more visible to the human eye.

It really *was* a dark and stormy night when Cosmic Society members embarked on our investigation of the nineteenth-century whaling ship called the *Charles W. Morgan*, permanently docked in Connecticut's famous Mystic Seaport since 1941. I wanted to be sure it had all the haunted qualifications required for inclusion in my tours. As it turned out, the *Charles W. Morgan* had all of these and more!

The history of this vessel is quite interesting. She was built in 1840 at a cost of $43,849.85 for a Quaker whaling merchant named Charles Waln Morgan. She launched her maiden voyage on July 21, 1841, and through eighty years of service she sailed more miles in pursuit of whales than any other whaling ship on the seven seas. She made thirty-seven voyages ranging in duration from nine months to five years and had twenty-one captains, five of whom had their wives and families onboard. Each voyage averaged about thirty-three crewmen per trip. In total, her berths rested over one thousand whalemen of all races and nationalities who worked the decks together—a testament to their ability to overcome racial prejudice. The crew onboard the *Morgan* was sometimes called a "checkerboard crew" due to the variety of skin color—black, red and white. There are unsubstantiated tales of the ship being part of the "Freedom Train." The train carried the original versions of the United States Constitution, Declaration of Independence and the Bill of Rights on its tour of more than three hundred cities in forty-eight states as a way to reawaken Americans to the principles of liberty

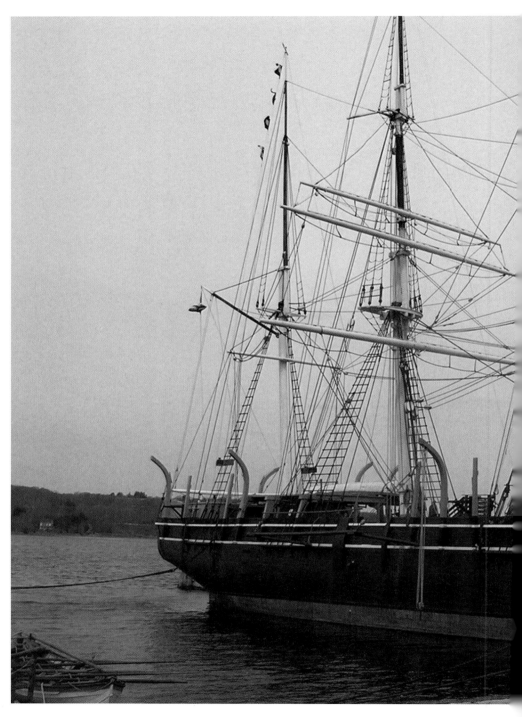

The *Charles W. Morgan*.

The *Charles W. Morgan* and the Buckingham House, Mystic Seaport

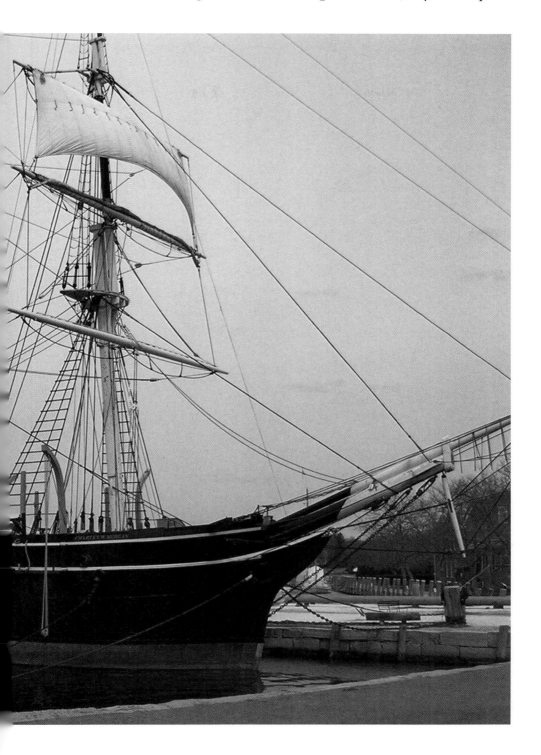

that many had forgotten or taken for granted in the postwar years. It was also established that Charles W. Morgan, the man for whom the ship was named, was a fierce abolitionist.

One month before Pearl Harbor, the *Morgan*, beaten up by the 1938 hurricane and years of abandonment, almost sank into the Mystic River before reaching the sand and stones of the seaport where she sat for thirty-two years. In January 1974 she was freed from her former berth and restorations began.

The *Morgan* stands today as America's oldest wooden whaling ship, *the sole survivor* of a fleet that, in 1846, numbered 736 vessels. The *Morgan* weathered more than her share of brutal and deadly maritime adventures, and it's possible that those who worked her might have stayed aboard, even after their physical deaths.

The *Morgan* survived a fire in New Bedford, Massachusetts, when a steamer named *Katy* caught fire. Her ropes aflame, the *Katy* drifted into the *Morgan*, catching the *Morgan* on fire in the process. Ice and snow were other perils, and one of the ship's captains lost his son when he fell overboard and froze to death in the water during a winter storm. The ship was attacked by cannibals in the South Seas and defended by the whalemen with harpoons. Imitation gun ports were either painted or nailed to outside of the vessel to dissuade potential pirates. Many times the whales themselves would purposely attack the vessel, hurling their massive frames into the wooden hulls in an attempt to fight off capture.

Imagine the dangers and conditions the crews faced on their journeys. Isolated and lonely, away from loved ones and family, harsh conditions, seasickness and the ever present danger of imminent death wreaked havoc on their emotions. Many captains were downright fiendish, some were religiously delusional and many committed suicide if mutiny didn't kill them first. All of these adversities—the emotional torture, physical abuse and insanity—make the conditions for a haunting quite ripe.

While Betty and I were scouting out the *Morgan* the first day, we stepped onboard, and I felt nothing abnormal (or paranormal) on deck of the ship. However, when we entered below deck and made our way to the very lowest level, I immediately sensed a shift in energy and thought, "Well, if there's anything here, this is where I'll find it."

When we arrived with the full Cosmic Society crew one night, we began by breaking up into smaller groups of two and three and exploring the different areas of the ship. We set up the electronics in the hull, and what started out as normal filming lasted about three minutes. Then, all at once, every camcorder and audio device was drained of energy. Fully charged battery packs were now registering empty on all of our equipment. All

The *Charles W. Morgan* and the Buckingham House

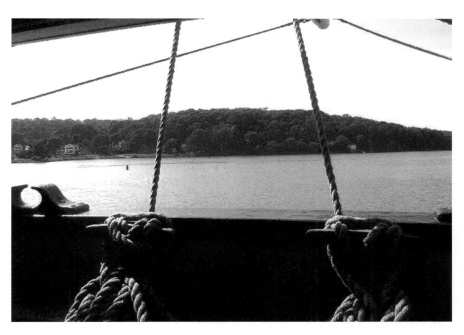

A view from the deck.

A video camera set up during a Cosmic Society investigation of the *Morgan*.

the gear was running on separate batteries—nothing was plugged into outlets. The odds of such a widespread, simultaneous battery power outage occurring by pure coincidence are almost little to none.

On the upper deck, one of our members had a feeling of lightheadedness and breathlessness and began sweating profusely, but only from the neck up. The rest of her body was abnormally cold. This phenomenon happened only onboard the ship, and she returned to normal when we disembarked. She also smelled a cherry-scented tobacco in the captain's quarters where, of course, no one had smoked for years.

In the summer of 2006, I received a letter from a CosmicSociety.com website viewer with these comments:

Dear Donna,

I attended your Halloween tour last year and I am disappointed that I can't attend your meetings. I am excited, however, that you will be investigating the Morgan *in Mystic. I had an experience there when I was touring the boat. As I was walking through the captain's and sailor's quarters, I felt an intensely oppressive feeling. I felt as if the boat was still populated. When I walked past one of the sailor's bunks, I had a mental flash, or visualization of a man in his late twenties or early thirties. He was sitting on his bunk, leg bent, and foot on his knee, reading a book. He looked up from his book and gave me a cold, hard stare. I felt a sense of resentment and curiosity. The oppressive feeling finally got to me after that and I had to leave the boat. If it's still there, you might also want to check out the* Australia. *Last I knew it was a wrecked ship in one of the buildings. You used to be able to walk through the ship. I did several years ago and I felt that same oppressiveness as on the* Morgan. *When I got home that night I had consistent nightmares. Just flashes of being on that ship and desperate people trying to communicate with me. I felt their fear and desperation.*

Jennifer Rivera

The ship has other claims to fame aside from its haunts and history. The *Charles W. Morgan* appeared in four movies, three of which were filmed prior to 1940: *Miss Petticoats* (1916), *Down to the Sea in Ships* (1922) and *Java Head* (1934). In 1997, Steven Spielberg used the "blubber room" of the *Charles W. Morgan* to depict the hold of the slave ship *Amistad* for his movie of the same name.

The *Morgan* is also credited with saving the seaport financially. Acquiring the ship just prior to the Great Depression created a huge boost of interest in the seaport and ever since has brought in record numbers of new visitors.

The *Charles W. Morgan* and the Buckingham House, Mystic Seaport

Crewmen's quarters aboard the *Morgan*.

In 1967, by order of the secretary of the interior, the *Charles W. Morgan* was formally designated a National Historic Landmark, and the United States Postal Service issued a commemorative stamp honoring the vessel in 1971. The *Associated Press* reported that trees downed in Hurricane Katrina were donated for the extensive renovations of the *Morgan* planned for 2007.

On September 10, 2007, Brian Jones and I revisited the seaport to make final evaluations before writing this chapter. A security officer directed us to Howard W. Davis, interpreter at Mystic Seaport, who granted us a candid interview about his own history with the *Morgan*. The interview has been edited down to the most essential information:

> DK: *Tell us first about you.*
> HD: *First, ya gotta know, I got seventeen years background in shipbuilding in commercial yards. In 1958 there was no more wooden boats to build. So, Mystic Seaport offered me a temporary job here in September of '58. They only promised me a job through January of '59. And so January '59, he said, "You're in the budget. They raised you $2 an hour."*

Howard Davis, a living icon at Mystic Seaport.

DK: An impressive boost in salary!
HD: So I've had some raises but I'm still in the budget. So, thirty-one years I worked in the shipyard here…restoration of the ships and now I've been talking about it for seventeen. So I've got forty-eight and a half years in as of now. Well, I'm aiming for fifty at least.
DK: Wow!
HD: Now, my grandfather had told me, "Never work in the shipyard"—because he had for most of his life—"and never be a ship caulker." That's the one that makes the ship watertight, because he had been a caulker. So, I did not become a caulker. I learned to build the boats. My father went in the office and kept the books. My grandfather was a caulker and my other grandfather was a sail maker. So, I came by this naturally, so they say. When I came here, they said, "You got your grandfather's caulking tools?" So there's a picture of me over on the wall caulking on the side of the **Morgan.** *And then, for thirty-one years, I did the woodwork, the caulking…we did a lot of the woodwork inside the* **Morgan,** *and on the outlaying decks, and I caulked a lot of the top of the* **Morgan** *and the decks and just general work here. When the* **Morgan** *job was done, we worked on other boats. This shop was built in 1971 and a lift was put in. But we did not have that when the shipyard was here in 1971.*

The *Charles W. Morgan* and the Buckingham House, Mystic Seaport

DK: *Very interesting, Howard.*

HD: *But we worked on the* Morgan *when it was in the bed of sand, before it came down here.*

DK: *When was that?*

HD: *It was in the bed of sand from 1941—when it came in November '41, until December of '73, when we took it out of the sand.*

DK: *Wow! For thirty years!*

HD: *For thirty-two years—in the sand!*

DK: *That's a long time!*

HD: *Then…then the winter of '74, we re-caulked the whole bottom of it and that hasn't been done since. And now, they've got to do some work on the bottom, as well as do some woodwork, as well as caulking.*

DK: *As far as any ghost presences or strange experiences, being that you worked on that ship so long…tell me about them.*

HD: *Now I tell ya. There's a rumor about ghosts on the ship, but, uh, I've never seen the one they talked about, but I have seen one of my own: A fella who used to work here with us…and when another fella and myself were working down below, putting in the captain's cabin and so forth, we used to eat lunch with him in the storeroom. So, he was older than we were, and he died, and then I found myself* [unintelligible] *and one night a few years ago, I was closing up the ship, turning out the lights and I swore he was in that room with me! I had that feeling he was right alongside me. I looked, there's nobody there. And a young lady, who would work on the ship that morning, had the feeling he was aboard the ship that day. So, I told this story on* Good Morning America.

DK: *You did? Wow!*

HD: *So…so, that's the main thing and I'm still here!*

DK: *Yes you are Howard!*

HD: *And I hope to stay!*

DK: *What was this gentleman's name, if you know?*

HD: *That I don't want to say.*

DK: *Okay.*

HD: *Because his children and grandchildren are still around.*

DK: *Understood.*

HD: *Right down the church there, I told the story, and they asked his name and I told them, "I'm not gonna say because his grandchildren go here." So. .anything else?*

DK: *What about the Buckingham House?*

HD: *I don't know a thing about that.*

BJ: *Any other co-workers talk about ghost experiences that you have heard?*

HD: No, I haven't talked to any of 'em. In fact, most of the fellas who work in the shipyard now are younger and weren't here when I worked there. There's only two in the shipyard who were in when I was here.

DK: How about some seafarer's superstitions?

HD: Superstitions? Well…I, I did put a curse on a boat we were building.

DK: Oh my! Tell us about that!

HD: Well, you never wanna turn a hatch cover upside down on a boat.

DK: Never?

HD: Never. That's bad luck.

DK: Oh, okay…

HD: So, we were building this new boat in the shop that'd never been finished, and I was putting preservative on the hatch cover, so the easiest way to do it was flip it over and do the inside…and the fella having it built, he went right through the roof—said I was tryin' to condemn his boat. And he went to the boss and he was really upset over it. But…when we launched it, there was a terrible crack and we ended up puttin' a hole in it when we launched it [laughs]. So, I figured it was my fault. I put the curse on it. And we couldn't haul it out again, because we didn't have water enough to haul it out. So we had to bring it to Mystic (this was a yard in Noank)…had to bring it to Mystic and haul it out and put in two new planks.

DK: Isn't that something…

HD: So, that was on a brand-new boat—the first time she'd been in the water.

DK/BJ: Wow!

HD: See, I put a curse on it.

DK: You did! Do you feel guilty about that?

HD: No. No, I don't. But the boat's gone now. They took it down to Louisiana and I guess it was lost in a storm somewhere. I don't think it lasted 'til Katrina. They took it down in the early '80s.

DK/BJ: Thank you, Howard, for all of your time and knowledge of the seaport.

HD: You're quite welcome.

The Buckingham Hall House

Another marvel of the seaport's rich history is the Buckingham Hall House, which arrived in 1951 by barge from Old Saybrook, Connecticut. The kitchen area dates from 1695 and the main house from the 1760s. While

The *Charles W. Morgan* and the Buckingham House, Mystic Seaport

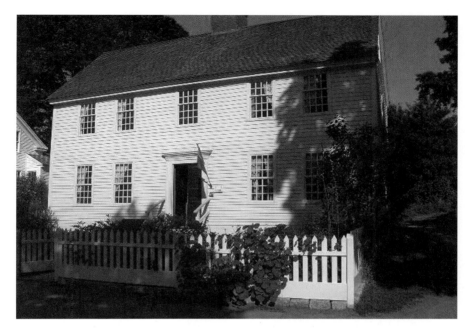

The Buckingham House at Mystic Seaport.

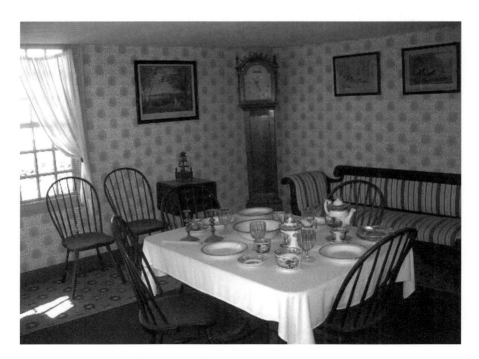

The dining room at the Buckingham House.

The photo Brian Jones snapped just as he heard a disembodied voice dance around him.

filming the *Amistad,* one of Steven Spielberg's assistants was looking out from an upper window and kept feeling a hand tap her on the shoulder. Members of the movie crew and museum workers reported hearing unexplained screams coming from the building.

The house is thought to be haunted by two women and a small girl. One docent at the historic dwelling jokingly held up her glass of wine and inquired what the former Mrs. Buckingham "would think of the women of today's era drinking alcohol on her premises." At that moment, the guide felt a sharp slap on her hand, and the glass of wine went flying, smashing to bits when it hit a wall. This happened right in front of a roomful of astonished tourists.

Like others before her, so dedicated to their lives and jobs at the shipyard, Mildred Mallory, who created the museum's membership program, is rumored to remain in spirit after her death and is often credited with moving small items around the building and manipulating telephones.

When members of the Cosmic Society visited the house, we were immediately drawn to the upper rooms where many of us sensed a playful youngster. Brian Jones was taking pictures of the canopy bed when to his right he heard the laughter of a little girl, loud and clear. Like a child playing she ran around behind him from right to left, unseen and giggling.

Matt did not feel much in the house until he went upstairs. While he didn't see or hear anything, he did sense one or two spirits present. The first he determined to be a child as he felt a sense of innocence, fright and overall childish energy. The other spirit was adult, and Matt felt that it was not connected to the child. While confident that the child is connected to

The *Charles W. Morgan* and the Buckingham House, Mystic Seaport

the house, Matt was more uncertain about the adult spirit's energy. There was a point in the investigation when Matt was sitting on the stairs and he felt the ghostly child descend the stairs and sit down next to him. Seconds later he felt a tug on his jacket.

We left the seaport and the ghosts, but if nautical spirits intrigue you then I urge you to pay a visit to the Mystic Seaport and make your acquaintance with their cadre of ghosts!

The Whitehall Mansion, Mystic

The name Whitehall is actually derived from the name Whight House (named after a forebear's home in Essex, England). The Whitehall Mansion in Mystic was named by one of its earliest owners who had acquired the property through land grants set up for pioneers.

The foundation was built in 1680, and the first dwelling constructed above was erected by Lieutenant William Gallup, third son of Captain John Gallup, to be used as a home. Lieutenant Gallup was protective of and friendly with the conquered Mohegan Indians. The building that stood on the site from 1750–1755 was once a tavern and stagecoach stop on the well-traveled Old Turnpike that ran from New York to Boston.

Dr. Dudley Woodbridge purchased the land from Lieutenant Gallup and Whitehall construction started in 1771 (to be completed in 1775) on top of the former building's foundation (the building had been razed). Many speculate that the basement at one time or another may have served as a store or tavern.

The attic had an area that was believed to be a secret room. By removing floorboards next to the chimney, access was granted to the room, which may have housed runaway slaves. The room supposedly led to a passage, which tunneled to the riverbank. Excavations for road construction revealed no such passage. However, the drainage ditch could have served the purpose. A house nearby was known to have been a station of the Underground Railroad, and the neighboring cemetery was the final resting place for many freed slaves.

Dr. Woodbridge was a prominent physician, and the house served as a doctor's office and clinic for his patients, in addition to being the family homestead. Woodbridge's family consisted of his wife Sarah and their nine children: Benjamin, Lucy, Charlotte, Sally (nicknamed Sarah), Samuel,

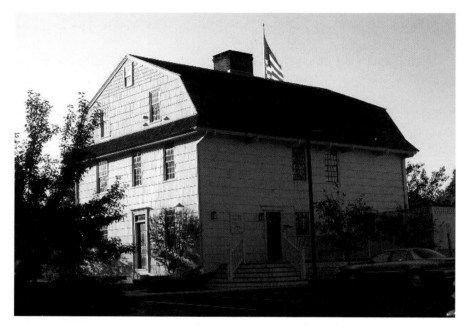

Whitehall Mansion.

Cosmic Society investigator Rich "Colonel Cosmic" Keegan checks out a secret passage.

The Whitehall Mansion, Mystic

Elizabeth (nicknamed Betsy), Joseph, William and Dudley Jr. The spirits of Lucy and Benjamin may still reside in the house.

Dr. Dudley Woodbridge descended from a long line of ministers dating all the way back to 1492 in Wiltshire, England. His American ancestors preached throughout Massachusetts and into Connecticut, with his father being the first minister of Groton. In addition to being a doctor, Dudley studied theology at Yale and then transferred to Harvard where he earned his degree in 1724. Dr. Woodbridge had his hand in politics and public service and sat for Groton in the General Assembly at Hartford from 1735 to 1762. He contributed to the Revolutionary War, being named on several committees up until 1779.

Dr. Woodbridge died on October 4, 1790, and the *Connecticut Gazette* published his eulogy. In it they praised his "reputation for success in the medical profession and in business transactions, as a man of temperance, unblemished morals and serious religion—leading an exemplary life of virtue and piety."

Sarah died in 1796, and all the children were married and living elsewhere, except for Lucy, who had never married, and Benjamin, who died at age twelve.

The house eventually ended up in the hands of the Rodman family through marriage into the Woodbridge family.

In 1852 Joseph Wheeler purchased Whitehall Mansion. Wheeler was a hardworking farmer plagued by bad luck after he inadvertently plowed some of the Whitehall Cemetery land. The town required him to replant and smooth over the damage. He suffered from consumption (tuberculosis) and moved to Florida in hopes that the warm climate would provide a remedy, but to no avail. He returned to Mystic, but the disease forced him to give up farming. When he died in 1872, the house was willed to his wife and three daughters. His last remaining daughter, Florence Grace Keach, inherited the house after her sisters' deaths.

Florence, in an attempt to save Whitehall from demolition for the construction of an interstate highway, donated the mansion to the Stonington Historical Society in 1962. After tremendous efforts on the part of the Historical Society, Mystic Seaport, the Stonington Garden Club and numerous other organizations, the building was ultimately spared from destruction. Florence also donated $15,000 and five acres of property for the relocation of the mansion.

It was an enormous and difficult project to move the building. Chimneys had to be photographed and then dismantled. But after much careful planning and labor, Whitehall was repositioned on as much of the original foundation as was possible and reoriented to face west towards the highway.

Restoration was completed in 1965. In 1966, a caretaker's wing was added, and the building was equipped with electricity, water, plumbing and portable electric heating. In 1968 the original color schemes and design of the Woodbridge-era home were implemented. The house was not moved far from its original location. The Waterford Hotel Group purchased the property and now runs it as an inn.

The Whitehall Burying Ground is "across the road and towards the river."[1] The Woodbridge family as well as many other prominent early New England families are interred there. Some gravestones date back to the 1600s. The graveyard has an underground vault that was used during colonial times to store cadavers during winter months when the ground was too frozen to dig graves. In the spring the bodies would be brought out of the vault and buried.

For our Haunted Connecticut Tours, Betty Cordellos and I visited with Whitehall Mansion's former sales and service coordinator in August 2006 to discuss the possibility of including the mansion on the tour roster. We are not willing to allow any location on the tour without first thoroughly investigating many factors including the structural integrity of the building, the site's ability to accommodate tour guests and the degree of spirit activity present. During this first brief trip I captured many orbs on my camera—in the basement, attic, in Betsy's quarters and in the bathroom of Lucy's quarters. It was agreed that the Cosmic Society would be allowed to investigate the mansion at some point in the coming months.

Our opportunity came less than three weeks later on September 15, 2006. The weather conditions were stormy and rainy earlier in the evening, but the inclement weather had stopped by the time we reached Whitehall.

I had been informed prior to arrival that each room contained a journal for guests to record their impressions of their stay at the historic home. Below are excerpts from guest entries, depicting some visits from beyond:

Betsy's Chamber

May 11, 2002—"At night I was sleeping and I woke up [and] *my leg was lifted and dropped down. While I was in the shower my husband said that the door opened. He wanted to know if I left it open. That was highly unlikely.*"

August 6, 2003—"*Last night, both Dave and I tried to open the cupboard where the TV is lodged. We couldn't. This morning, Dave opened it*

The Whitehall Mansion, Mystic

The mausoleum at Whitehall Mansion Cemetery.

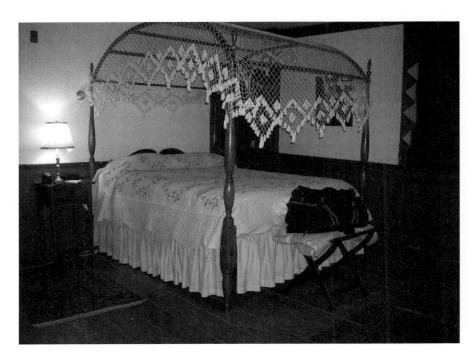

Lucy's Chambers at Whitehall Mansion.

without a problem! We decided Ms. Betsy did not want the TV to ruin our romantic evening!"

October 11, 2003—"We slept well but wonder if Betsey [sic] *may have played with the bed canopy overnight. In the morning we noticed that it was all crooked over the bed."*

February 18, 2005—"Heard odd noises all night coming from within the room and its walls. At one point, near the fireplace, we heard the distinct sound of a baby crying. We could feel the presence of something here; as the previous authors of this journal said, a friendly presence. No poltergeists—don't worry!"

January 16, 2006—"Strange noises at 4 a.m. in empty room next door—Lucy's Parlor."

Sarah Sheldon Parlor

April 10, 2005—"…and my only spirited experience was early in the a.m. A man's voice sounded three times with a humming tune!"

January 14–16, 2006—"…but before bed my husband was sitting in the chair reading. I was on the bed. I felt something touch my head like a finger run through my hair. I shook it off like as though a bug was on me but there was nothing. I can't explain it."

Benjamin's Hall

August 26, 2003—"We came here for the romantic atmosphere and we also wanted to investigate the rumors that the mansion was haunted. Imagine our surprise when, in the middle of the night, we heard loud moaning emanating from the room next door. We believe it was a friendly ghost, but more investigation is needed."

Woodbridge Hall

November 3, 2002—"Last night I dreamt of a special person who may have lived here. He or she came to me in a dream, making me feel welcome."

The Whitehall Mansion, Mystic

April 8–9, 2006—"On a bit of a strange note, the right hand glass door on the fireplace likes to open by itself. Keep an eye on it."

Lucy's Parlor Chamber

July 10–11, 2003—"I do believe Lucy was here. The pictures were moved on the wall! Watch that tall floor light by the window—it was out in the middle of the floor by morning."

April 9, 2005—"Last night Lucy pulled my arm at the elbow and woke me up."

April 10, 2005—"At early dawn this morning I heard soft step-toeing [sic] up the stairs and a single soft tap on my door and one on Betsy's door but no sound of anyone going down the stairs."

The Whitehall Mansion is the residence of many, many spirits. They are quite active and want to be recognized. We sensed spirits of varying ages and time periods. None, so far, show any malevolent tendencies. The next visit to the mansion conducted by Cosmic Society would provide a good opportunity to try to directly communicate with the earthbound spirits to help determine their identities. A trip to the Whitehall Burying Ground was on our agenda as well.

Literally hundreds of digital and 35 mm photographs were taken during Cosmic Society's overnight stay, and a large portion of these show spirit activity in the form of orbs.

The Cosmic Society's second visit to the mansion on April 6, 2007, began with a trip to the family cemetery. The day was overcast and gray, but luckily it didn't rain. We tracked down the graves of Benjamin and Sarah and visited the open crypt. We found the grave of an African slave who had been emancipated in life but was still segregated in death, buried at the far end of the graveyard away from the others laid to rest there.

It was during my fourth visit that the spirits really wanted to be heard. Brian and I spent the night there, on May 12, 2007, for my birthday. We stayed in the same room we had on the last visit—Benjamin's Hall. Almost from the time we arrived, we sensed that Sarah and Benjamin were vying for our attention. We heard snippets of voices, never quite discernable, and saw numerous blue and white sparkly points of light that zipped around our room like cars on a racetrack. Just as we were about to fall asleep, Brian heard the sound of a coin or pen hitting the glass tabletop and rolling

Benjamin's grave.

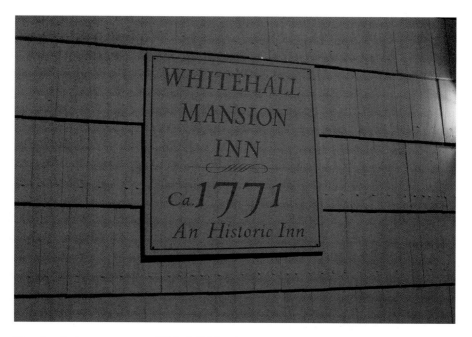

The sign that greets guests at Whitehall Mansion.

across it. Brian nudged me and asked, "Did you hear that?" He got up to investigate. I couldn't say with certainty that I had, as I was already half asleep. I was awakened at 3:15 a.m., however, by the sounds of footsteps just outside the doorway from the foyer to our guest room. I couldn't see a thing, but I heard the footsteps continue past my side of the bed—it seemed they were purposely thumping dramatically, and just as I elbowed Brian to wake him up, they ceased. I no longer felt a presence in the room, and I let Brian continue his sleep uninterrupted. For me, it wasn't that easy to get back to sleep.

Below I have included excerpts from our investigator's notes and our overall report to give you, the reader, an idea of how we gather and document information:

Chris N. & Rona K.:
Chris and I did not get anything on film at the mansion. We both heard what sounded like footsteps up the stairs, stopping at the landing and touching our door handle. This was after Leanne had left. We opened the door [and] nobody was there. [We] shut the door and the footsteps went down the stairs about halfway and stopped. In the attic there was movement, footsteps and a loud bang overhead.

Leanne and A.J. R.:
We took two pictures that showed orbs from the Whitehall attic and the front room. The only thing we can note is the fact that some pages were "missing" from the guest book in our room. [T]he others on the top floor were intact. A.J. went to bed and I didn't know he didn't check the other rooms on the first floor until our ride home (at 5:00 a.m.!).

Margaret S.:
I didn't capture anything on video film or audio, nor did the gauss meter[2] react. I did however get orbs in the pictures of the attic ([where] I felt the most activity…) and in several of the guest rooms. While we were in the attic we did have some interaction with the spirits who responded to our urgings to do something… [W]e asked the spirits to "touch the orange extension cord" and at that point several orbs gathered around that area in our photos. I felt nothing negative at the mansion. [I]n fact the place is very peaceful. I loved the place and want to go back. The next day I took a series of photos in each of the rooms. The most active areas were in the attic and around the loveseat in Lucy's room. I also got a few random orbs in some of the guest rooms.

Mary Q.:
The attic was the most active place in this home. I definitely felt an "energy shift" upon entering the building. I sensed multiple "entities" and "cold spots" but they were all of a benevolent nature. The atmosphere was most positive. Just after lying down in bed, the room went from comfortably warm to very cold and something touched my arm. I heard noises (like something was being moved) and footsteps on the attic stairs. I had many orb pictures but all of my photos were somehow deleted from my digital camera.

Brian J.:
I entered the attic space [and] got an orb on film right away in the back, unlit area of the attic.

 I also saw orbs without the aid of equipment several times. The basement seemed especially quiet during this visit. While staying in Lucy's chambers, Donna and I were asking spirits to show themselves on our camera and we were getting orbs almost every time in the places we felt spirits were manifesting themselves. Most interestingly, I could just barely see and hear a girl of about twelve or fourteen, dressed in an old-fashioned wide-skirted dress and full bonnet. She was frantically waving and calling out to us, "I'm here! I'm right here! Why can't you see me?!" She was frustrated and very eager for us to be able to interact with her.

Donna K.:
While taking pictures in the basement I saw a translucent looking "man" walk from right to left near the fireplace screens. I watched him take about four steps and then he just disappeared. He was middle-aged, non-descript, about five foot eight and looked to have thinning grayish brown hair. He looked straight ahead (not towards me) as he walked and so my view of him was of his left side. The attic gave me a feeling of vertigo somewhat (which often happens when there is a lot of spirit energy concentrated in one area because of the physical body's biological reaction to higher than normal levels of electromagnetic energy). My entire bag of ghost hunting equipment was left at home so I only had my digital camera to work with the entire night of three full investigations…

Mathew N.:
I really didn't feel anything here; more than likely because of the fact that I was very tired as we had just come from fully investigating two other

The Whitehall Mansion, Mystic

The attic at Whitehall Mansion.

locations in Mystic in the pouring rain and at the same time I was full of Coca-Cola, so basically all of my senses went straight out the window. I did however hear noises such as footsteps and even voices, but other than that found the house to be very peaceful. I sensed an older person's spirit as well as those of young people. I feel that whatever was in residence here was looking for peace and quiet. Hopefully they don't have to sleep on the couch…that ice machine is LOUD!

Whitehall Mansion is truly a beautiful place to stay, and I encourage you to make the trip, but you just might find that you are not the only guest occupying your quarters!

Elizabeth Shaw and the Windham Inn, Windham

Windham, Connecticut, was established in 1686. The green lies open in the center of town surrounded by a circle of historic Colonial homes and buildings as though time here never moved beyond the eighteenth century. Windham, seat of the county court, was the place where people being sued or tried for crimes were judged, juried and even executed. The town's residents settled into a serene, devout and simple life. However, the events that soon unfolded in this sleepy little hamlet shook everyone in the town out of tranquility.

On November 18, 1744, a young, simple-minded woman was tried for a most foul crime. The charge was infanticide. It seemed that Elizabeth Shaw (Betsy) wasn't of much value to her family as she could only handle the simplest of chores. She was most likely considered a burden—just another mouth to feed in a family already struggling to survive. The Shaws were a farming family, and life was not easy.

When the childlike woman, unmarried, discovered she was pregnant, she became more than just a burden. She was now a liability. People wanted to

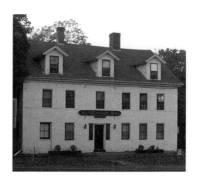

The Windham Inn, on the Windham Green.

Tour guests listen to the dynamic and fascinating Bev York on the Windham Green.

know who the father might be, and it was even speculated that Elizabeth's own father could be the culprit.

The nine-month pregnancy must have seemed like nine years to Elizabeth. Although accustomed to being taunted and scorned by the townsfolk, she could no longer bear the insults and accusations. After its birth in September the baby immediately vanished. It was later found dead near a cliff in another part of town called Hampton.

Medical authorities were unable to determine whether the baby was born dead or alive, and soon young Betsy found herself being charged with murder. Betsy's father turned her in, perhaps as a way of distancing himself from his shameful offspring or as an attempt to absolve his own culpability in the crime.

There were no insanity clauses in the system in 1745 when Betsy was brought to trial. Nine jurors, all men and all upstanding members of the community, felt strongly that Elizabeth Shaw did not have the right to live. It was decided that she be scheduled to hang in December. It was also decided that the executioner would be a man named Winthrop, and court records show that he was paid twenty-nine pounds (about fity dollars at the time)—an exorbitant amount for carrying out the deed. In fact, it was more than most folks made in a year.

Elizabeth Shaw and the Windham Inn, Windham

Plains Road, where Betsy's funeral procession travelled and where she has been seen today.

As this was to be Windham County's first public execution, the town faced the dilemma of just where to hang Betsy Shaw. The town declared that the new Gallows Hill should be located down by the river. The Windham area was first inhabited to take advantage of the river's water power for saw-and gristmills, which led to the development of the thread and textile industries. As time went on, the town became revered as one of the world's premium manufacturers of thread outside of England and was suitably nicknamed Thread City.

The bitter New England winter did not deter the crowds, and everyone came to witness the execution. Miss Shaw was made to sit atop her own coffin on the horse drawn carriage leading the procession to Gallows Hill. Legend says that her frozen fingers tapped loudly against the pine box—so loudly that they sounded like nails being driven into the casket. In front of a gawking crowd, the hanging commenced as scheduled. No one knows where Betsy's remains were buried, but it doesn't seem to matter because she is certainly not at rest. Betsy Shaw can still be seen pacing the roads of Windham today.

Since the hanging, every year in November, on especially harsh winter days, a woman in white matching Elizabeth's description has been seen

walking up and down Plains Road. This is the last place that the fog lifts in the village. The woman is apparently looking for something that belonged to her; perhaps something that had been snatched away from her and the only thing she ever loved—her baby. Encounters with Elizabeth, both on the streets and at the site of the former Windham Inn, continue to astound the eyewitnesses who have crossed paths with her.

One day, a college professor pulled his car over to help what he could only describe as a "woman in distress, wearing clothes inappropriate for the season." As he rolled the window down to ask if she wanted to warm herself and get a lift into the next town, the woman vanished right before his eyes.

The Windham Inn at the time was called an "ordinary." Here you'd get an overnight stay and a meal—it was the bed-and-breakfast of its day. The Windham Inn stood on the town green bearing silent witness to the trial of Elizabeth Shaw, but Elizabeth Shaw has been anything but silent in the Windham Inn. Now converted into apartments, the building and its occupants—especially young, single mothers—have been confronted by an angry ghost, most frequently in the months from September to November.

A young woman who lived alone on the first floor and was meticulous about keeping her doors locked, arrived home from work one day to find both the front door and a window wide open. In her living room she found a framed baby picture turned over and smashed into tiny glass shards. The picture itself had been removed from the broken frame and lay crumpled on the floor.

Another sighting occurred as a female tenant was letting herself into the main entrance. As she stepped inside, a woman in white approached her from out of nowhere and passed by as she inserted her key into her apartment door. Noticing that the strangely clad woman had stopped in front of a neighbor's door, the tenant commented that the apartment's occupant was not yet home. The woman in white instantly disappeared.

Yet another single female and her two-year-old son had a brush with the ghost of Elizabeth Shaw. The son, who had never misbehaved in his entire two years, began acting strangely when they moved into the apartment. From the very first night the child did not sleep and acted wretchedly day and night. However, every time they left the building, the baby reverted back to his cheerful self. Doctors could find no reasonable cause for his unrest and even medicine didn't help. His mother had the eerie sense that someone or something was constantly watching her and her child. She felt that an unseen presence pervaded the tiny apartment. Only when her "feelings of doom" became overwhelming did she pack up their belongings and abandon the apartment. Her child never behaved in such a wretched way again.

Elizabeth Shaw and the Windham Inn, Windham

Elizabeth Shaw had a hard life. The abuse she suffered at the hands of those she trusted was inconceivable. Poor Betsy's spirit cannot seem to resolve the loss of her child, and she lingers in Windham, searching fruitlessly for her baby. She was most likely an innocent victim of ignorance. After her baby was taken from her and killed, she was persecuted relentlessly, executed unfairly and buried anonymously.

When visiting Windham, Connecticut, and the town green between September and December I suggest that you keep an eye out for Elizabeth Shaw.

The White Horse Inn at Vernon Stiles Restaurant, Thompson

Sitting quietly in the center of Thompson right on the edge of the green is the White Horse Inn at Vernon Stiles. Thompson is located in the most northeastern corner of Connecticut, bordered by Rhode Island to the east and Massachusetts to the north. In the 1640s this was Nipmuck territory, and coaxed by Christian missionaries, over one hundred Nipmuck people set up camp there. A gigantic wigwam was built, which could still be seen as late as 1730. *Quinnatisset* was the Nipmuck word for their territory—the area now known as Thompson Hill—and translated it meant "little long river" or "long brook."

For Thompson, its location was a launch pad for prosperity. Three important rivers run through the town. The French and the Quinebaug pour through the west side, and the Assawaga (also called the Five Mile River) flows down the east side. The town survived for all these years on the production of the mills that were functioning along the riverbanks. Streams and reservoirs sprung off of these rivers creating a complex and copious system of waterways that made manufacturing plants plentiful and mills abundant.

The Native Americans around Thompson were among the first natives to convert to Christianity in America. By 1650, native converts to Christianity had begun moving to Natick, Massachusetts, to organize what would become the first of several villages known as "praying towns." The Native Americans who resided in these towns were known as "praying Indians." By about 1660, seven new praying towns were established in Nipmuck territory, including three, which existed in present-day Windham County. Here, as in all of the praying towns that followed, Native Americans renounced their native language, ceremonies, beliefs, traditional dress and customs—effectively becoming "red" Puritans.

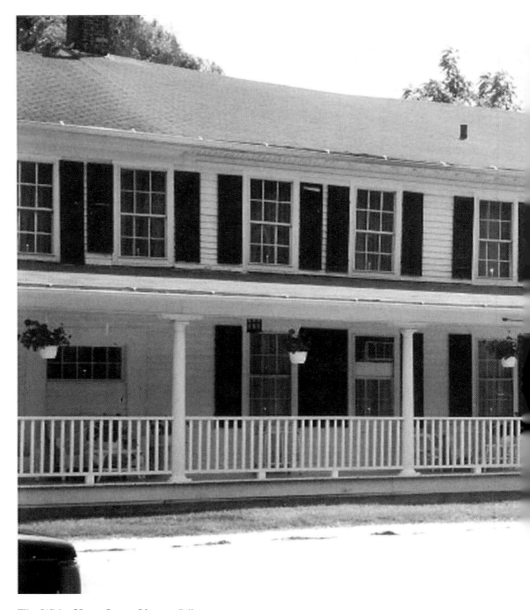

The White Horse Inn at Vernon Stiles.

The White Horse Inn at Vernon Stiles Restaurant, Thompson

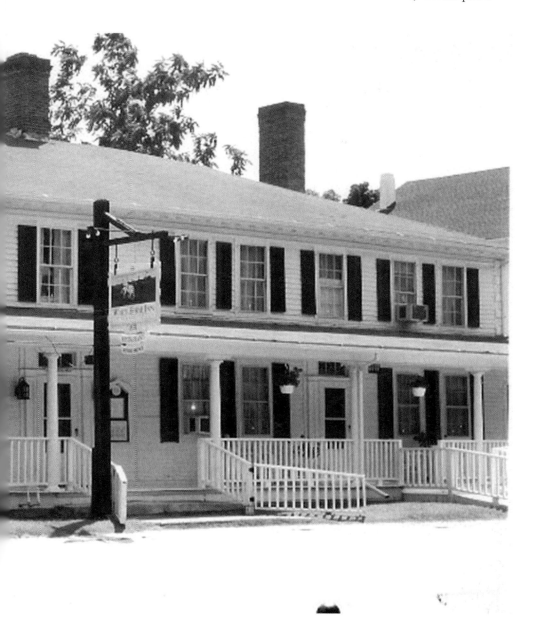

King Philip's War quickly undid the missionaries' efforts. The Quinnatisset Nipmucks joined with the Narragansetts and were mostly destroyed. Many Native American utensils and arrows have been found in the Thompson vicinity.

After the settling of Native American affairs following King Philip's defeat, five thousand acres of land at Quinnatisset were included in the reservation allotted to the native tribes. This land was immediately made over to the Massachusetts agents Stoughton and Dudley. On June 18, 1683, they conveyed over two thousand acres of this land in the Nipmuck country, including the present Thompson Hill and surrounding land, to a nonresident English gentleman.

Scattered over a wide section of wilderness, settlers built log houses on the land. They knew so little of each other that three families established on the eastern frontier in 1721 supposed themselves to be the only inhabitants north of Killingly.

The area soon to become Thompson was traversed daily by stagecoach and horseback travelers from the south to Boston and from Providence, Rhode Island, to Springfield, Massachusetts. Today's Route 193 was originally the Boston Turnpike—a toll road. The Stiles Tavern was a convenient overnight stop on this route, and it claimed that more travelers stopped there on a daily basis than at any other house in New England. The tavern was named for its most famous owner, Captain Vernon Stiles, who was described as the *"beau idéal* landlord" or the perfect host. The tavern, now known as the Cottage House, serves as a country resort and getaway spa in the center of Thompson Hill. Many witnesses claim to have seen Captain Stiles as well as a number of other phantom residents still wandering the halls and rooms of the location.

The first structure on the site was built in 1754 as the dwelling of Samuel Watson. The present building was constructed in 1814 and passed through several owners' hands. It is a long structure, and for years it housed several businesses in addition to the Tavern—a Colonial era strip mall of sorts. The two intersecting lines of turnpike on Thompson Hill generated a healthy and booming economy there. Before 1800, the Joseph Watson house, Wickham's Store and Keith's Tavern sprang to life at the site. In 1813, George Larned Esq. purchased the north end of the hill from Watson and divided it into several lots. Larned himself occupied the Watson house as both a home and a law office.

Hezekiah Olney, born and raised in Thompson, was high sheriff of Windham County for three terms and built a brick block between the Stiles Tavern and a town house on the north end. He turned it into the New York Hat and Cap Store. As United States assessor, Mr. Olney administered the

affairs of the Thompson Bank and served as town representative at the legislature, in addition to being sheriff and postmaster. One reporter of the day portrayed him as "a dignified gentleman of the old school, spare in form, immaculate in dress, with a fine command of language, a strong sense of justice and whose brave utterances command the most respectful attention."[3] In 1880 Olney was elected to the responsible position of school fund commissioner.

Others who used the site for business in the early 1800s were Obadiah Stone, a shoemaker, and Horatio Paine, a boot manufacturer. Mr. Noadiah Comins built the house that adjoins the tavern on the south side and operated a saddler's shop there. Dr. James Webb built a third house nearby, but went bankrupt, or, as quoted from the day, he "unfortunately miscalculated his balance sheet and was obliged to take unceremonious leave of patients and creditors."[4] Dr. Webb never finished building the house and left town, so Dr. Horatio Holbrook became the town's physician.

The tavern site soon became the town's meeting hall and then was turned into a town house. The heart of the present tavern was put up on the corner by Stephen E. Tefft. In 1830 Edward Shaw of Providence, Rhode Island, ran a jewelry store out of the structure.

Whether any of these businesses actually thrived is unknown, but the turnover rate seems to suggest that most "wanted out" as fast as possible. The town had become a gathering spot for transients and drunkards. A number of shops and stores along the green were replaced by grogshops to meet the rapidly increasing demand for drink. It was the eastern version of the Wild West!

Things began to stabilize, however, in 1831 when Captain Vernon Stiles of Millbury, Massachusetts, quit his job as manager of a hotel and took over as innkeeper at his Stiles Tavern. Business thrived and Stiles, only in his early twenties, bragged that "more stagecoach passengers dine in my tavern in Thompson than any other tavern in New England." Stiles was a gregarious and outgoing person, a skilled public speaker and a nimble politician. The Democratic Party made his bar its headquarters and his dining room the scene of many merry celebrations. Location also played a prime role in his success, as the tavern was situated dead center of two major travel routes—the roads from Boston to Hartford and from Providence to Springfield.

Just as Connecticut shared its borders with neighboring states, Captain Vernon Stiles shared his homestead with many notably unusual friends and prominent associates. Business was booming and Stiles's list of guests was of a high caliber and a fascinating nature. Included in the roster were the Marquis de Lafayette and his aide-de-camp, Rochambeau.

Lafayette was a French nobleman and an officer in France's army. He was an invaluable asset to the Americans during the Revolution and served

George Washington faithfully during the war. Stiles commemorated de Lafayette's visit by changing the official tavern sign into a portrayal of the marquis arriving on a carriage and tipping his hat. The sign also held encrypted markings for members of the secret Freemason's Society.

The Wedding Factory

In the 1830s the Stiles Tavern became something of a "wedding factory," as the laws in Connecticut only called for one "publishment of intent to marry" so that couples could marry without delay. Other states required at least fifteen days (or three consecutive Sundays) of waiting—much too long for most eager, young couples. This was before the process of taking years to plan the perfect wedding was popularized. Couples could decide on Sunday morning to get married and be dining on the readily available wedding cake for brunch that same day. Perhaps the only comparison today might be the Elvis Chapels of Las Vegas.

This "marriage machine" presented a few minor dilemmas. The lack of ministers versus the abundant demand for marriages forced the clergy to officiate a brief reading of marriage intentions during Sunday services followed by a small ceremony afterwards. Puritans criticized the "alarming Sabbath-breaking" of the clergy. As a solution, Captain Stiles was appointed a justice for the services of matrimony. Known to conduct the marriages in a lighthearted and jovial fashion, he quickly became the most in-demand wedding officiator in the area. Thompson became widely known as the "Gretna Green of New England" with runaway couples furnishing funding for improvements and filling the pockets of local wedding suppliers. Only once in a blue moon did a Sunday morning pass without the encampments and legal entanglements of matrimony being performed.

Near the tavern, in the town house building, Stiles participated in a debate society that hotly discussed the issues of the day. One of the most debated subjects was that of temperance. The Washingtonian Temperance Movement gained steam, and many were in favor of instituting it in Thompson. However, others viewed it as a violation of their rights and bitterly opposed it. A pub called the Wilks House generated especially obnoxious behavior by drunkards and the proprietor was considered a man of ill repute. When a patron died after being left out in a barn in freezing weather one night, the temperance advocates had the ammunition they needed to proclaim reform. In deference, Stiles closed the pub area of the building for a period of time during the Temperance Reform Movement. While the Old Town Hall was being constructed, townsfolk held their

The White Horse Inn at Vernon Stiles Restaurant, Thompson

meetings in the gathering place of the Stiles Tavern.

Thompson Hill increasingly buzzed with activity and commerce. Rum was freely sold in all the stores and taverns, and people indulged in drink to excess, prompting the local preacher to deliver his first temperance sermon. Lorenzo Dow later became known as the preacher who denounced the existence of a God. "Who hath woe? Who hath sorrow? Who hath contentions? Who hath babblings? Who hath redness of eyes? They that tarry long at the wine!" he bellowed. However, the pastor's own indulgence in a glass of wine at the house of a parishioner somewhat nullified the credibility of his previous day's fiery sermon. Temperance reform still came into effect and liquor was eliminated from common household use, social occasions and the more upscale stores.

The Four Train Wreck, East Thompson

East Thompson is the site of the only four train wreck in the history of the United States. The wreck took place on December 4, 1891, resulting in two grisly deaths. Within a matter of minutes, two freight trains crashed head on, and then a third passenger train smashed into the debris of that wreck. Unbelievably, a fourth passenger train soon arrived and slammed into debris of the three train collision. A red-hot poker was shoved through Fireman Gerry Fitzgerald, killing him. Engineer Harry Tabor was decapitated. Red-hot steam shot out of the engine of one train. The quick thinking of a conductor, Frank Jennison, probably saved many lives. As he left the mangled train he turned off the valves to the gas lighting preventing a disastrous fire. The people sleeping in the Pullman sleeping cars didn't have any idea what had happened. Shocked and dazed, they stumbled out of the smashed cars to safety. When Engineer Tabor was found, his pocket watch was forever stopped at 6:47 a.m. Amazingly, only two trainmen were killed and one passenger, R.H. Rath of New York, was never found but believed to be burned in the wreckage. The stunned and bewildered residents of East Thompson witnessed over five hundred feet of twisted wreckage and debris covering the tracks. Witnesses have reported today seeing one or two men wandering the vicinity of the tracks and then disappearing before they could be approached.

Like the living, ghosts enjoy company, and I have noticed that where you find one, you find more. The town of Thompson is not at a loss for wandering souls of the departed.

Vernon Stiles is said to "walk the house" and has been seen standing in

the upper window in full regalia uniform. Most recently, a woman who is well acquainted with the inn (and one not given to flights of imagination) drove by the building and saw Captain Stiles, fully dressed in uniform, staring at her from a top floor window. She almost drove off the road and upon returning to work called to ask if the inn was holding some sort of reenactment. This happened around the end of July or early August 2001.

The general feeling is that if you are being respectful and trying to "do well" for the establishment, then Vernon is happy. He had a reputation for being an upstanding, distinguished, well-spoken and well-mannered person as well as a great host and skilled politician.

Emma is said to be the girlfriend of a chef who hanged himself on the basement stairway. In 1999 a waitress heard a noise, turned around and saw the image of a woman who vanished instantly. Various guests of the inn have also reported seeing a woman disappear. Emma is thought to "walk" the upper hallway near the women's restroom, although she has also been seen on the first floor.

The fireplace in the area just outside the women's room sparked into flame by itself once, yet all of the fireplaces had been converted to a central gas fuel system, which must be switched on manually before lighting an individual pilot light. It cannot just spontaneously light by itself.

David Bergeron, a former general manager, has felt a cold chill in the spot where the chef killed himself, although he personally does not put much stock into ghosts and hauntings. He describes himself as the type who needs to "see it to believe it." He does admit, however, that there are things he witnessed at the inn that he cannot rationally explain.

The management office is located upstairs and Bergeron has mentioned seeing images and shadows in the hallway mirror which is situated within view of his desk. He has also heard unexplainable noises such as footsteps while working alone late at night. However, he did not sense anything negative or threatening.

"I refuse to go into the burned out area, period, and I will not work here at night," says Meg, an assistant at the inn. She has seen and heard a lot of unusual things while working in her office on the upper floor. There are padlocks that can only be opened with combinations, and Meg continues to find them unlocked without a natural cause. Another waitress told her of going upstairs and hearing her name called. Upon turning she found no one there.

Meg is psychically intuitive and sensitive and can feel Emma's presence. She hasn't felt her in the inn lately. She feels that Emma does small mischievous things such as turning lights back on after Meg knew she had

The White Horse Inn at Vernon Stiles Restaurant, Thompson

turned them off.

During my brief visit to the inn I felt a strong sense of female energy, both in spirit and more generally, in the building. The restaurant's décor has a decidedly feminine theme. I feel strongly that the spirit of Emma is there to protect and preserve in some way the staff and the clientele. I feel she stays and defends the living from the lingering and resentful energy of her boyfriend who committed suicide by hanging in the cellar stairway.

Nine different sets of hands have held the inn as their own since the days of Vernon Stiles. Today it is known as the Cottage House and runs as a bed-and-breakfast.

The Bloody Orchard, Franklin

The apple has a long and dubious history. Since its reputation as the original forbidden fruit and the temptation, which led to the "fall of man," the apple has gotten the bitter end of the deal. Even in Connecticut, eating apples that grow with bloodstains on them makes for a disturbing experience.

Legend shows that Micah Rood was true to his name. He was obnoxious to almost anyone and everyone who crossed his path. His neighbors did not care for him and that was the way he seemed to like it. However, Rood didn't start out that way. Micah didn't have any friends his own age, but in the beginning it was thought that he at least harbored a kind of fondness for the local children. They'd pass by his farm on their way to school, the first in Franklin, which was built on Meeting House Hill, and he'd be there with a large basket, filled with apples and would allow each child to pick one. His orchards were well-known throughout "the Square" and his apples were coveted as the spiciest, juiciest, most tasty varieties of the fruit to be found. Farmers begged for shoots of the splendid trees, but Micah, sensing their value, would always refuse. The famed orchards were making him more than a modest living, and he was determined to keep it that way. In the midst of his zeal, something seemed to happen to warp his demeanor, and there was a great deal of speculation about what that something was. He suddenly became inaccessible and unfriendly to others.

Perhaps it was his greed or pride that brought on the winds of change. Some attributed his new and morbid outlook to witchcraft or an ungodly interest in the occult. An increasing insanity began to accompany his wickedness and isolation, and he stopped attending Sunday services at the adjacent Congregational Church. It's possible that his madness was inherited—his father was hanged at the gallows in October 1672. He was

Woods now cover the grounds that once hosted the Bloody Orchard.

the first colonist in North America to be condemned to death on the charge of incest. Micah's oldest sister Sarah narrowly escaped death by hanging because the court was convinced that her father had forced her into the situation, which resulted in a baby boy named George. In *Public Records of the Colony of Connecticut from 1665 to 1678* by J. Hammond Trumbull[5] Sarah's fate was recorded as thus:

> *Court held at Hartford November 8, 1672.*
> *This court considering of Sarah Roodes case doe take notice of a great appearance of force layd up upon her spirit by her father overaweing & Tiranical abuse of his parentall authority besides his bodily striveings which not onely at first brought her into the snare but also in after yielding to his Temptation & the consealment of the fact & cause of being with childe which kind of forceing to a person so ignorant & weake in minde to withstand the Temptation These & the like Grownds doe render her not equally Guilty but that as the fathers fault was much aggravated so the child's is exceedingly mittigated thereby wherefore the sentence of this court is that shee be severly whipt on the naked body once at Hartford & once at Norwich that others may heare & fear & do no more such abominable wickednesse.*

Another theory holds that the spirits of tribal natives were disturbed by the crimes of the Rood family—of which murder and incest were only two—and these acts were committed on Native American burial grounds, on top of which the Rood orchards were planted. The lands had been granted to Thomas Rood, Micah's infamous father, when Norwich was founded in 1660, and the property markers as well as the Mohegan graves appear on the Book of Grants "to the first mentioned white oake which is marked and is standing neare the graves."

Whatever the reason for Rood's psychological alteration, the children were the first to experience the dual nature of the man they had come to know as their friend. At first they wondered if something might be wrong when he was noticeably not present on their daily treks to the schoolyard. Maybe he was ill. Their parents observed that the previously abundant orchards began to wither, and the lands he once tilled received less and less attention. The house he had lived in with his sisters, brothers and mother (who had all died there) became run down, reflecting the declining state of the land outside. The youngsters' concern quickly turned to fear when, hoping they might just get some of those delicious apples unnoticed or perhaps lingering around the farm outskirts a little too long or maybe venturing in a little too far, they were sent screaming for their lives. More than once it was said

that old Rood would hide in the orchard or just behind the fieldstone wall and, donning a hideous mask, jump out and scare children or anyone else who thought they might taste one of his marvelous fruits for free. He took great pride in his apple trees and was no longer willing to share any of the proceeds. His miserly ways extended to the absurd—he went to bed at dusk in order to conserve candle wax.

Rood's descent into lunacy may well have begun in the spring of 1693 when Micah Rood and a stranger in town crossed paths. A peddler arrived at the Franklin Green to sell his wares of cloth, tin pans, trinkets and toys. He was shabbily dressed and spoke with a thick accent, but the exquisite treasures that he was pawning made the local puritans take pause and notice. He spent the day explaining his goods and convincing the townsfolk to buy them. Apparently, he was a slick salesman, and by day's end his purse was bulging and his sack of goods was almost empty.

One of his final customers had offered up the name of Micah Rood along with short directions to his farm after the salesman inquired about local lodgings. Peddlers weren't generally welcome at the inns, and even so, the nearest was hours away. As the stranger headed out in the direction of the Rood farm neither he nor his customer could have known that this would be the last time anyone in town saw the old man alive.

Suspicious at first, Micah was reluctant to allow the peddler entrance to his home. Until, that is, he was offered cash in exchange for a room. With uncharacteristic giddiness, Micah set about playing the good host, even lighting his savored candles well beyond his normal bedtime. He offered up a cup of broth to the stranger for an extra coin. Feigning compassion, he attempted small talk with his houseguest, especially interested in his day's take. His obvious aim was to glean just how much loot, in the form of cash, heirlooms or gems, the old peddler had on him.

The peddler was a seasoned salesman and stayed alert at the line of questioning. The farmer seemed to live a pauper's life and was a little too fascinated with his earnings. He had almost been robbed the previous night at the Blue Horse Tavern and hadn't reached his ripe old age by being foolish.

Turning in for the night, he hid his purse in his bag and went to sleep holding onto it tightly. Unfortunately, he would never awaken to see it—or daylight—again. His bruised and battered body was found early the next day lying in a shallow grave underneath one of Rood's beloved apple trees. His bag and a few items were found scattered nearby, but there was no sign of his purse or the coins it contained.

The local constables initiated an investigation, which pinpointed Rood as the most likely suspect. Rood vehemently denied having any part in the

The Bloody Orchard, Franklin

"snake-oil salesman's" murder, suggesting that perhaps it was the previous night's villains from the tavern returning to get the peddler's second day take. He admitted that the man had spent the night, but was certain that he had been accosted after leaving his dwelling. The authorities countered that no strangers had been seen in the neighborhood. Rood reluctantly allowed them to search his home, but they found no signs of digging and, more importantly, no signs of any coins or large sums of money. There was no evidence to connect Rood with the murder, and no charges were ever filed. The peddler's body was buried in Potter's Field.

Time and seasons passed and soon it was again spring in New England, and the much anticipated apple blossoms were beginning to bloom. Strangely, they weren't their usual pink and white color—instead they were streaked blood-red. The closer one came to the spot where the peddler's body was discovered, the darker and deeper the crimson splotches became. The neighbors watched as the blood-red petals fell from the trees, and summer turned to autumn, making the fruit ripe for the harvesting. Micah Rood no longer discouraged neighbors, kids and townspeople from picking his precious apples. Rather, he encouraged them to take all they cared to, shouting at one young teenager, "I don't want the accursed things!"

Word circulated and the villagers speculated that the murdered peddler had cursed the land not only with his dying breath, but with his very life's blood as it drained into the roots of Micah's precious fruit trees.

Rood's hermit-like existence and extremes in behavior were now exacerbated, and the farm continued its suffering, failure and decay. It is said that Micah's physical health mirrored that of the blight on the property. He suffered from a lack of appetite, horrible nightmares and obvious paranoia. He was seen peering out of the windows by the unusual glow of a candle that he kept burning until the early morning hours, haunted by the dark and whatever specters may have been cloaked within.

The aftermath of all of this left Micah Rood a changed man. Court records of the day attest to his poverty, and he went on what was the public assistance of the day, receiving help from the Franklin Congregational Church:

> *October ye first day, 1717. Ye society agreed by their vote yet each family shalt give Micah Rood a Peck of Corn for sweeping ye Meeting House one year.*

The records of the ecclesiastical society, still extant, also contain these entries:

A view looking up at the sky, from the spot the peddler lay as he took his last breath.

July 5, 1727. The inhabitants do now, by their vote, agree to allow to each man that watches with Micah Rood, two shillings per night. Also to those who have attended sd Rood by day, three shillings per day.

December 17, 1728. Jacob Hyde was awarded 30 shillings for digging Micah Rood's grave.

I was fortunate enough to interview the current owner of the private property and was allowed to venture into a small area of the former farm for a brief photo shoot. Bordering the Susquetonscut Brook, an offshoot of the river, Rood's property was in an area of Franklin known as Peck Hollow and is today relatively unchanged in atmosphere. There is deciduous young forest growth and a few cottage-like houses in a typically rural, serene New England countryside. Across the street from the old Rood orchard are the remains of a gristmill called Franklin's Crossing, and the Congregational Church that supported Rood until his dying day still stands on the hill overlooking the land that saw more than its fair share of hard times.

Time heals all wounds or so it is said, and Mother Nature reclaimed the infamous tree where the peddler's body was found in the fury of the

The Bloody Orchard, Franklin

The remains of the mill at Franklin's Crossing.

great hurricane of 1938. The tree was located about one hundred yards from the stone wall. Descendents of the original trees were said to produce apples with one bloodstained spot in the center for many decades after the curse, and "Mike's" or "Rood" apples, as they were known, were sold commercially as late as the twentieth century

If by chance you happen to bite into a bloodstained apple, take a minute to think about how the marks got there and the sad history behind the blood-red droplets.

The Lighthouse Inn, New London

The smell of bat urine was overwhelming. Holding my breath and a Bic lighter, I crept forward into the musty catacomb. I noticed modern day items like paint cans, broken chairs and rusty shovels, but aside from these it seemed almost like a mine shaft with arched, corrugated tin ceilings, wet brick and stone walls and earthen floor. I sensed something ancient down there, something intangible yet very real; something embedded in the walls and ground of the tunnel.

It is not known when these passageways were built, but they were probably used for bootlegging during Prohibition given their proximity to the direct waterfront less than a quarter mile down the street. I was able to crawl in about four hundred feet before coming to an abrupt stop—the tunnel was cemented shut, and I was forced to turn back, a situation which I admit was a bit of a relief as I was in desperate need of fresh air. As I started back, I was overwhelmed by the eerie feeling of something lurking just behind me; something that—if it had a face—would have been looking over my right shoulder. I could sense it there keeping pace with me as I carefully maneuvered my way back to the cellar of the Lighthouse Inn of New London, Connecticut.

Initially known as *Nameaug* or "good fishing place" by the Pequot Indians, New London, founded in 1646, is a port city. Situated at the mouth of the Thames River, New London has an extensive maritime history. This "whaling city" is home to Fort Trumbull, the United States Coast Guard Academy and Connecticut College near the northern harbor. It even boasts the nation's oldest operating U.S. customs office in the historic downtown waterfront area. The Garde Arts Center, also downtown, is well-known for housing the Eastern Connecticut Symphony Orchestra. For roughly 130 years, New London has hosted the Harvard-Yale Regatta, the oldest

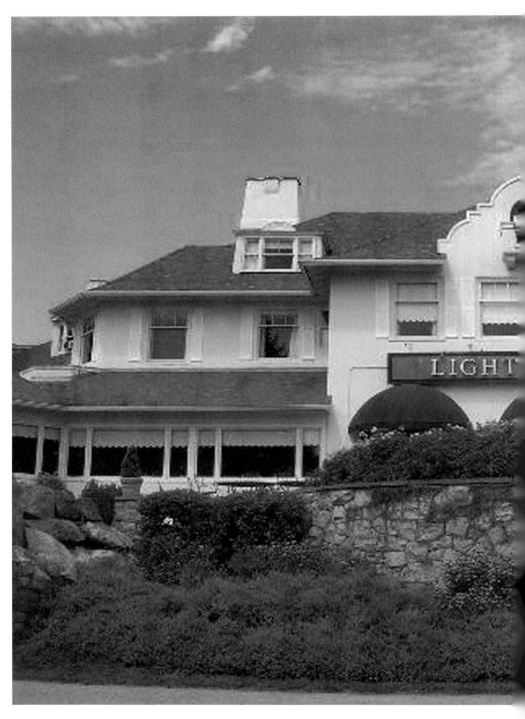
The Lighthouse Inn.

The Lighthouse Inn, New London

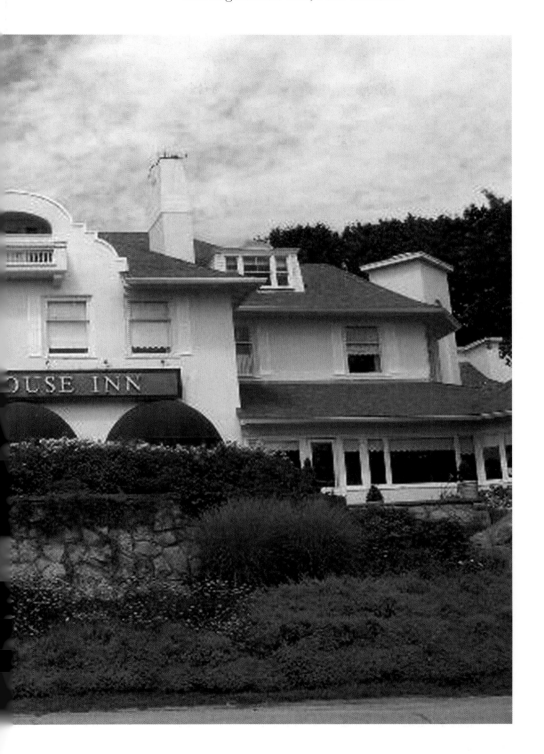

Left: The author, Donna Kent, in the tunnel below the Lighthouse Inn.

Below: The end of the tunnel, with a surprising and mysterious feature: a human skull imprinted on it.

Opposite: A close-up of the human skull imprint.

intercollegiate sporting competition in the U.S. With its bustling shipyards and marinas and busy seaports and piers, it was the favored destination of various American entrepreneurs as a versatile getaway location. It was easy to yacht to exotic places or stay at the seasonal resorts there. The area was conducive not only to holiday visits, but was also an excellent place to network with other wealthy industrialists and business moguls. So enticing a destination it was that when summertime faded into fall most did not want to leave. Some of these former visitors and residents chose to remain, even after death, at the Lighthouse Inn.

Originally built as Meadow Court in 1902 as a summer residence for Charles Strong Guthrie, a Pittsburgh Steel tycoon, and his wife, Francis Amelia, the Lighthouse Inn is one of New London's most impressive waterfront properties. Renowned architect William Ralph Emerson envisioned the building to "capture sunlight and the exterior world of nature."[6] Frederick Law Olmsted, who also designed Central Park in New York, was the landscape architect. The lush grounds, which reached to the shoreline, were filled with perfectly groomed lawns and blooming gardens and were featured in the 1912 issue of *American Homes and Gardens*. These flourishing blossoms earned Meadow Court its name.

Unfortunately, Mr. Guthrie enjoyed only four short seasons at his estate before he died in 1906, at the relatively

young age of forty-six. Mrs. Guthrie continued to visit during the summer season until 1925 when the property was subdivided and sold.

In 1927 Meadow Court reopened its doors as the Lighthouse Inn, owned by two local businessmen. It was an immediate success. The inn became a popular meeting place—sort of an unofficial country club for the area's elite. Those in the spotlight appeared in the *New London Day*, the region's newspaper, which chronicled the daily activities of the inn's most notable residents. Proximity to local playhouses and theaters attracted guests such as Joan Crawford and Bette Davis, and celebrities and stars of all types still visit the inn today.

A year after its opening—and continuing for the next happy ten years—a private nursery school called the Pequot Day School was run in the building. Then, in 1938, a great hurricane struck coastal New England and led to the untimely deaths of two youngsters at the nursery. Staff and guests still hear these toddlers to this day. According to Kevin, the current food and beverage director, "Everyone hears them running up and down the stairs and around on the third floor, bounding a ball off the wall and laughing."

From New York to Maine, the hurricane struck without warning, and the havoc it wreaked forever changed the life and landscape of New England. Fordham University's seismograph recorded the hit as if it was a major earthquake, and to this day it is remembered as one of the worst disasters in North American history.

Waves rose well over ordinary heights, crashing and crushing and bringing death and destruction upon coastal Connecticut and the entire New England shoreline. Winds were measured at over 120 miles per hour. The storm devastated New London. Not only did the community suffer the hurricane with water pressure at full force, but the next day it was struck by another natural disaster—fire, the exact cause of which is still unknown. It took ten hours to battle the blaze that engulfed the entire waterfront. The damage amounted to the equivalent of $16 million in today's dollars. Any beach homes that weren't completely lost to the ocean or sea of debris were turned into smoky, warped ruins. The force of the hurricane actually relocated a 240-ton lightship over two miles from its original berth in the harbor, twisted steel beams like licorice sticks and tore entire top stories from buildings, damaging and/or demolishing over 75,000 structures. Too many unbelieving souls thought they could ride out the tempest and decided to "hunker down" in their cottages. Ninety-eight people died in Connecticut, one hundred went missing and over 2,500 were injured. Makeshift morgues sprung up, many with piles of only body parts. Survivors remember that the wind was so fierce and high-pitched that it seemed as if it was literally screaming. This catastrophe even spawned a book: *A Wind to Shake the World* by Everett S. Allen.

The Lighthouse Inn, New London

I took a tour of the Lighthouse Inn in the summer of 2006 with my tour operator, Betty Cordellos. We were led by Executive Marketing Director Karen Walkup who pointed out a few of the locations where there were reports of unexplained activity. The most famous area was the main staircase, which has its own unique history. William Emerson, who designed and built the main staircase at Meadow Court, was immediately contracted to construct the same exact staircase on the legendary vessel *Titanic*. The builders of the *Titanic* saw the inn's main flight of stairs and had to have one for their White Star Line flagship. Emerson sailed on the *Titanic*'s infamous maiden voyage and perished at sea. Although he never made it back alive, it is possible that his spirit lingers around the staircase. Emerson also built the elaborate wooden hutch located in the main hall near the stairway and across from the men's room as you travel between the front lobby and the bar. Perhaps his spirit is anchored here in some way by the objects he so loved creating and into which he poured so much time and skill during his lifetime.

Although the Lighthouse Inn has undergone millions of dollars in renovations, the beams, tunnels and even the baroque chandeliers and wall sconces with figurative and marine designs are all original to the building. Dee, the office assistant, couldn't find any explanations for some of her odd experiences in the building. She complained:

> *Too many times when I come in and turn the lights on in the morning, they (the ghosts) turn them off again! I wondered if there might be something wrong with the power here! Also, the banks of lights turn on and off by a central switch, yet the ghosts can and do turn single lights on and off individually.*

In the late 1920s a woman tripped on her wedding gown as she was descending the curved stairway. As she fell, her neck broke and she landed dead at her distraught groom's feet. She has since been seen often by patrons, staff and band members and is the inn's most popular resident spirit.

One lady, after hearing the story of the spectral bride, wondered out loud about the details of the wedding dress she had worn on that fateful day and also requested her room to be changed to the bridal suite. She then took a picture on the stairway, and a huge orb presented itself in her photo. She also heard sounds of children playing and laughing in the hallway directly outside of her suite.

When a professional photographer was working with cadets from the nearby Coast Guard Academy, taking their pictures to chronicle the

Ghost Stories and Legends of Eastern Connecticut

The central staircase, where the bride tripped and died on her wedding day.

The Lighthouse Inn, New London

The hutch also built by the stair master.

The main dining area of the Lighthouse Inn.

function they were attending, she was a bit dismayed to find orbs in almost every one of her photos. According to Dee:

> *These orbs are a common occurrence here. It doesn't matter what type of camera or film is used. Almost everyone who stays here is in love with the staircase and it is photographed daily. Our visitors constantly show us their pictures!*

When the bride isn't reliving her tragic demise on the staircase she's often spotted in room 26, the bridal suite. Undeniably the best room in the house, the suite is the very center room situated just above the inn's sign at the front of the building and boasts a window boxed balcony. The bride makes her presence known by sitting on the bed or merely gliding across the room.

Kevin, the food and beverage director, told of an unusual incident he experienced after six months of employment at the inn:

> *The bridal suite is usually really hot in the summertime. It was about 2:30 in the morning, and I came down to do the cash out and turn off the lights downstairs. Everyone was gone, and I shut the glass doors and then I noticed the lights were going on and off repeatedly. The hallway, where it usually feels about one hundred and ten degrees, was ice cold and there was frost on the glass!*

In room 1 the toilet often flushes by itself, and the seat has been known to go up and down on its own. At times the radio spontaneously blares without the intervention of a human hand on the dial. The radio manipulation and interference could be attributed to the bride.

It has been my experience in hundreds of cases that when paranormal activity continually occurs in bathrooms, you can usually infer that you are dealing with a negative spirit. It is easiest for spirits to manifest in small, tightly enclosed areas. Secondly, a bathroom represents waste, elimination, decay, odor, mold, mildew and germs. People usually use the lavatory or take showers alone, and they are often naked and vulnerable.

The ghost of famous golfer Payne Stewart has been spotted at the inn on more than one occasion. Why he haunts this location is a mystery, but his tragic plane crash is a well-known tale. One sighting happened just before news of the plane disaster that caused the athlete's death hit television and radio stations worldwide. It was October 25, 1999, and a deliveryman who was unloading boxes in the basement saw a man dressed in knickers and classic golf attire standing on the cellar stairway. Noticeably out of place, the worker was about to approach the man when he smiled and simply

The Lighthouse Inn, New London

Room 26, the bridal suite.

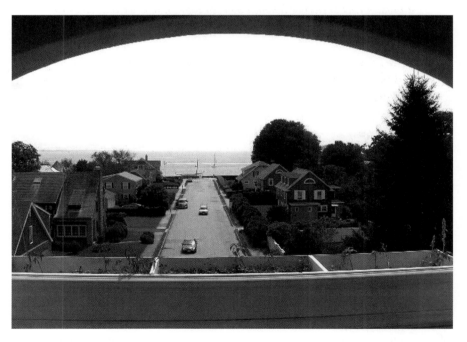

Looking out past the balcony of Room 26, towards the ocean. The street, now with houses, once contained the beautiful Meadow Court gardens.

Inside the bridal suite.

The Lighthouse Inn, New London

The toilet that flushes by itself.

disappeared. The dismayed deliveryman headed up to the bar and, after a stiff shot of whiskey, asked the bartender, "Who was the golfer I just saw in the basement?" Raising his brows, the bartender shrugged and went on with his duties. The next day as the details of Stewart's final flight became public and his picture was plastered on media outlets, the deliveryman recognized the dead man as the same one he'd seen in the basement of the Lighthouse Inn the day before.

Payne Stewart was indeed in crisis when the plane he boarded in Florida suddenly went into an unexpected flight pattern. Air traffic controllers could get no response from the plane and an F-16 jet was sent to determine what was happening. The F-16 also got no response from the distressed plane, but its pilot noticed that the windows were fogged over indicating a cabin leak, which caused the plane to lose air pressure. Passengers and crew were rendered unconscious and the plane flew on autopilot. The air force was ordered to shoot the jet down if it headed for a populated area, but after burning all of its fuel, the plane crashed in a field near Aberdeen, South Dakota. Stewart, along with five others onboard, had already died from hypoxia—lack of oxygen—before the crash and probably not long after takeoff.

The Lighthouse Inn, New London

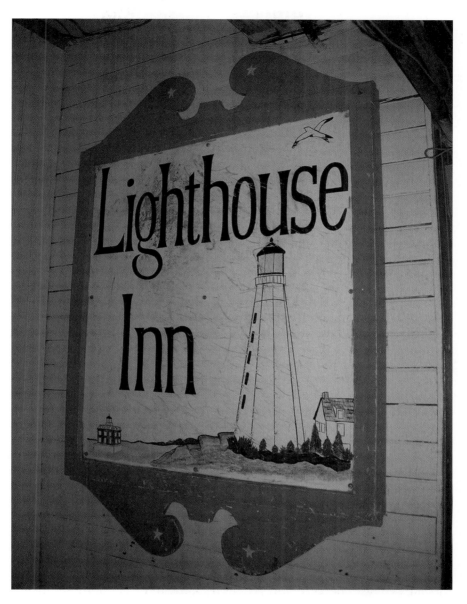

The Lighthouse Inn sign.

The rear entrance of the Lighthouse Inn.

The Lighthouse Inn, New London

The Travel Channel's *Haunted Hotels* featured the Lighthouse Inn in a 2004 segment, spending an entire weekend in New London filming and scouting around. A beacon for wayward spirits, the Lighthouse Inn is best experienced firsthand. I recommend that you reserve the bridal suite for a night, but be sure to watch your step on the stairs!

Eugene O'Neill's Monte Cristo Cottage, New London

It was on the day of Eugene's birth in a run-down New York City hotel room when his mother unwittingly began a descent into hell. The pain of childbirth and its accompanying complications led doctors to give Mary Ellen (Ella) O'Neill morphine—a drug she became addicted to for the rest of her life. "Drug addict" was not on her list of aspirations during her senior year of high school—she either wanted to be a nun or a concert pianist.

It was also on this day, October 16, 1888, that Eugene's adverse luck was set in motion. He was the product of a broken vow. Eugene's mother had sworn she would never have another child after suffering the death of her second son, Edmund. She left the toddlers in the care of her mother while she spent time touring with her husband. Her eldest son, James, caught the measles. In the 1880s, the disease was lethal to the infirm, elderly and infants. It was also extremely contagious. Ella wildly and irrationally accused James of deliberately exposing Edmund to his germs and subsequently causing the sickness that led to his baby brother's death. Perhaps it was easier to blame her own son than to admit to the guilt she felt at her absence. Whatever the case, James was shipped off to a boarding school.

Ella's husband and Eugene's father was James O'Neill, a well-known actor who toured the United States for years performing in the play *The Count of Monte Cristo* after which his "perfect vacation home" was named. James purchased a cottage overlooking the water in New London with the thought that it would delight his wife and family. His absence at Monte Cristo and a series of family misfortunes would soon prove him wrong.

The house was intended to be a summer getaway but ended up becoming the primary residence for Mary Ellen and her sons while her husband was traveling with the theater company. Her isolation and loneliness were exacerbated by drug-induced thoughts of fear, delusion and suicide.

The Monte Cristo Cottage.

James and Ella O'Neill, Eugene's parents.

Eugene O'Neill's Monte Cristo Cottage, New London

Perhaps she felt morphine was her only escape from the tragic realities the O'Neill family incurred, committed or experienced. They were nothing less than cursed.

Monte Cristo faces the ocean from directly across a narrow street. It was said that Mary Ellen hated the fog that swept in almost daily in New London and that her world inside the home was as gray as the one outside. In her distorted mind, the easiest solution to end her pain and suffering was to walk across the street and straight into the ocean.

The weight of his mother's addiction was too heavy for Eugene to bear. As a teenager he had walked in on his mother "shooting up." He rebelled against school and church, refusing to attend the latter. The only college level education he received before he was thrown out of Princeton University in 1907 for being a nonacademic drunkard was a playwriting course he'd taken at Harvard.

It is well-known that America's greatest playwright, Eugene O'Neill, attempted to commit suicide in a seedy boardinghouse room at the age of twenty-four. "I want to be an artist or nothing,"[7] he declared in 1913, not long after the attempt and while convalescing for a bout with tuberculosis in a sanatorium. It was at this time that he decided to become a dramatist.

Eugene married three times during his life and fathered a son, Eugene O'Neill Jr., whom he never saw until the boy was eleven. The boy, like his father, rebelled and often ran away from school. Heavy drinking and a hard life would lead to his suicidal death at age forty. Emotionally ruined by his own upbringing at the hands of unfit parents, O'Neill had a poor model for fathering his own children. He had tumultuous relationships with them all, and the generational family curse proliferated.

Eugene was out drinking when his second son, Shane O'Neill, was born. This would be the archetype of their relationship as O'Neill bore very little interest in the child. O'Neill did take the time to pen the youngster a letter when he decided to split from Shane's mother, his third wife, and wrote that he would not see Shane again for a long time. Shane, like his forebears, became an alcoholic and couldn't seem to find his place in the world. He was a drifter and a heroin addict. He did marry and fathered a son. However, two months later, doctors found the child dead and clear signs of neglect. Shane was arrested on drug charges. His father, disgusted, refused to see him again. Before he too killed himself, Shane penned a story about his family entitled "The Curse of the Misbegotten."

O'Neill's third child was a daughter whose first memories of her father must have been drunken arguments—her mother and father divorced when she was only four. Eugene seemed to bear only hostility for the girl as she grew older. He spoke of her as "a spoiled, lazy, vain little brat." At eighteen,

A placard tribute to Eugene O'Neill.

Eugene O'Neill's Monte Cristo Cottage, New London

Oona O'Neill headed for Hollywood, declining a college education at Vassar, where she dated famous older men including Orson Welles and J. D. Salinger. Her marriage to silent film star Charlie Chaplin, who was the same age as her father and thirty-seven years older than she, was the final nail in the coffin for her father who never spoke of or to her again. Oona and Chaplin enjoyed a loving thirty-four years together, against all odds, until death parted the couple in 1977. Debilitated by the loss of her husband, Oona failed at attempts in romantic relationships with much younger men including David Bowie and Ryan O'Neal. Oona's alcoholism led to her death by pancreatic cancer in 1991.

Eugene's childhood horrors relentlessly haunted him, and he penned them into angst-ridden, dramatic literary masterpieces. He is the only American to win the Nobel Prize for literature.

Eugene's father died in August 1920, and his mother sold the Monte Cristo cottage that she detested so much in life, yet now inhabits in death. Ella died of a brain tumor on February 28, 1922. A year later Eugene's alcoholic brother Jamie died at the age of forty-five. Ironically, Eugene O'Neill exited this world in a hotel room, dying in Boston on November 27, 1953, and telling his wife not to allow a priest to attend his funeral. He said, "If there is a God and I meet Him, we'll talk things over personally, man to man."[8]

The house became the setting for O'Neill's posthumously awarded Pulitzer prizewinning play *Long Day's Journey into Night*, which was clearly a dramatization of his own dysfunctional family and their lives in and out of the cottage. Director Jean-Marie Apostolides, of the Actor's Ensemble at Berkeley, said of the play "The references to ghosts are so numerous in *Long Day's Journey* that they force us to confront them."[9]

One night, after a holiday celebration, a former Monte Cristo resident by the name of Lenore and her friends were gathered around the piano singing and having a glass of wine. Standing beside her was a man she'd known for years. Members of the O'Neill family were no strangers to alcohol and someone made an offhand remark about the years of drinking the home had witnessed. No sooner were the words spoken than the glass was slapped out of Lenore's hand, spilling its contents and shattering. The room went silent, and a cold chill enveloped the guests. The man standing next to Lenore commented that he felt "something strangely electric pass by him towards Lenore just before the glass was displaced."

On another night, while sitting by herself in the den, Lenore sensed a presence and had the feeling that she suddenly wasn't alone. Her cat, at the same time, leapt off of her lap, hissing and growling at something Lenore was unable to see. One by one all of her animals gathered around her feet

Eugene O'Neill's Monte Cristo Cottage, New London

The piano in the front parlor.

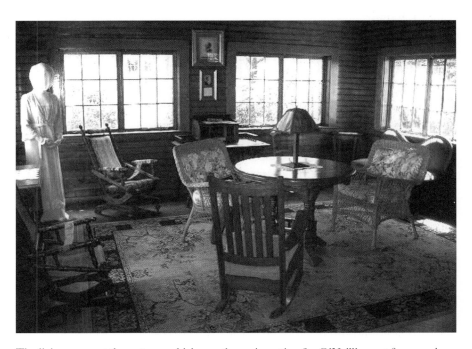

The living room at the cottage, which was the main setting for O'Neill's most famous play, *Long Day's Journey into Night*.

in what she described as a protective stance. She walked over to the stairway and, looking upwards, shouted, "We've all got to live here together, you know!"

An actor from the O'Neill Theater Center, Donny, was alone in the house one day, and as he descended the main staircase he felt a hand on his shoulder give him a hard shove. If not for catching the baluster on the stairwell, he would have been sent tumbling down the remaining steps.

More than mischievous, the male presence that makes the stairway his abode has a surly, mean and menacing vibration. One tourist with Haunted Connecticut Tours reported seeing a "very angry man" standing at the top of the stairs. She realized she could see right through him. "At that point," she said, "I couldn't finish the rest of the tour in there. I had to get outside. I never made it to the second floor." It is speculated that this spirit could be Jamie O'Neill, Eugene's brother, who was extremely close to his mother during life and an alcoholic who committed suicide.

Another tour guest pulled me aside after leaving the cottage in the summer of 2006 saying, "I know you didn't mention it, but I saw and felt a young boy, a toddler, following me around the entire time. Normally children's ghosts don't bother me, but this one was downright creepy!" There have been reports of a baby crying since 1974 coming from various areas in the dwelling.

Other tour guides have mentioned seeing a shadowy female figure, most likely the ghost of Ella, heading towards the window that faces the ocean at the end of the hallway on the second floor. Other times they've arrived at the top of stairs to find a woman standing at the window. She turns toward them and disappears. The sense of sadness and confusion connected with her is almost overwhelming, and many who have witnessed her ghost have left the area in tears, unable to explain their emotions.

The emotional states of spirits don't just change automatically upon physical death. If I had to guess, judging by the mindset of the O'Neill family, they're all probably still there in Monte Cristo. Eugene summarized his father's frame of mind this way: "My father died broken, unhappy, intensely bitter, feeling that life was 'a damned hard billet to chew.'"

For the psychically attuned, the cottage is a disturbing place, oppressive upon entry. I definitely picked up on what must have been Ella's unsteadiness, and I noticed that I walked with my arms out at my sides as if to steady myself. Granted, the house is tilted a bit. The imbalance of the building and its energy is particularly noticeable on the cramped second floor. One room, now an unorganized storage area, was closed off to the public. This was the room where Ella shot her morphine. I had the feeling of not being wanted in there; that I was an intruder. Guilt, shame and secrecy, combined

Eugene O'Neill's Monte Cristo Cottage, New London

The main staircase at the Monte Cristo Cottage.

The slightly leaning hallway upstairs at the Cottage.

with a drug-induced lack of balance, were the primary sensations that I experienced in this area.

I came away from the Monte Cristo cottage with a somber feeling of helplessness regarding the spirits that are trapped within. They seem to be caught in death in the same self-destructive cycles that they experienced in life.

Route 138—A Cruise Down the Vampire Highway, Jewett City

New England is a place where stories of vampires are plentiful. Many believed the old lore about "hungry ghosts" and reanimated corpses when their husbands, wives, sons and daughters were struck down, and they were convinced that the dead returned from the grave to suck the life and blood from the living.

In response to these beliefs, many burial customs and superstitions were diligently practiced to prevent the return of the deceased. For example, reflective surfaces such as mirrors or standing pools of water were covered after the death of a loved one so that the ghost could not see itself. It was believed that if a ghost saw its reflection it would want to stay earthbound and not move on into the "other world." Corpses were carried out of houses feet first in order to prevent their return (still in practice today). It was also common to bury people facedown, and heavy headstones were as much deterrents from rising out of the grave as they were memorial markers. Water moats and iron fences were often standard around a cemetery's perimeter in order to keep ghosts in (not people out) as it was thought that spirits could not pass through iron or over water. As the tuberculosis epidemic spread through the state of Connecticut, residents with dying and dead family members believed that these vampire matters "had to be dealt with." They took extreme and hideous measures to preserve the lives of their suffering, but still breathing, family members.

The Ray Family or "The Jewett City Vampires"

Due to their loss of many family members to tuberculosis, Jewett City's own Ray family became infamous in death for wild tales of vampirism. At the

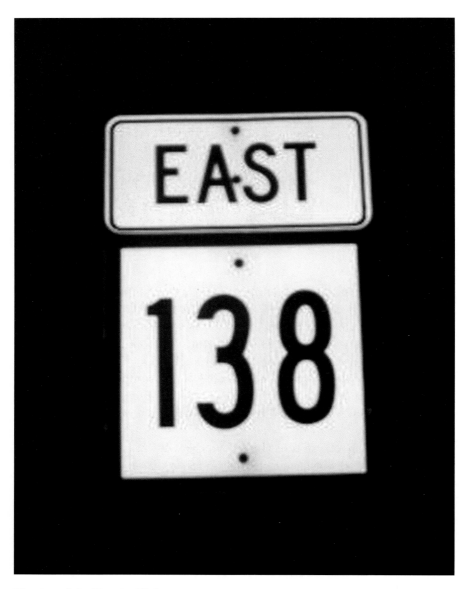

The sign of the Vampire Highway.

Route 138—A Cruise Down the Vampire Highway, Jewett City

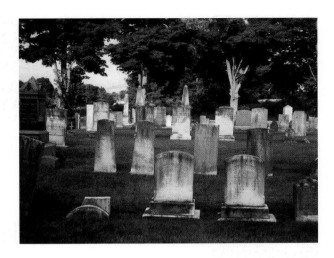

Here lay the remains of the Jewett City vampires.

time of the Ray family's tragedy the term "vampire" had been in use in the area for about one hundred years. In actuality, these "vampires" were all very human and very normal members of the Ray family in the nineteenth century. They were the father, Henry B. Ray, the mother, Lucy (Downing) Ray, and children Henry Nelson Ray, Lemuel B. Ray, Elisha H. Ray and Adaline Ray. In March 1845 Lemuel died of consumption at the age of twenty-four. Four years later, father Henry died of the same ailment. Two years after that, twenty-six-year-old Elisha joined them in the soft soil of the cemetery.

In 1854, when eldest son Henry Nelson was sick with the dreaded disease and near death at age thirty-five, the remaining members of the family—believing that Henry Nelson was sick due to his deceased brothers rising from their graves and draining his blood—took desperate steps to save him. In the pitch black of night on May 8, 1854, the Ray siblings and their mother snuck into the Jewett City burial grounds. They dug up their dead relatives and immediately burned their bodies down to ashes. For those who still refused to die, the corpses were decapitated and the head set between the feet. Organs, particularly the heart and liver, were roasted with ritual, mixed with liquids and eaten by kin to guarantee their security and safety from the return of the undead. No one knows if Henry Nelson ever did pull through his illness—his death was not recorded—but the death dates of all the other Rays have been properly recorded. If Henry did live, his family likely attributed his survival to their ghastly intervention.

The Vampire Highway

Route 138 is called "Vampire Highway," as it runs from Jewett City, Connecticut, to Exeter, Rhode Island. Rhode Island, being known as the "Vampire Capital of America," certainly has its own share of vampire stories. It is thought that the early beliefs and traditions regarding vampires trickled down into Connecticut from Rhode Island by way of this road, which at the time was most likely not much more than a cow path.

A recent unearthing of an old, abandoned, private graveyard occurred along the highway. Many families buried their dead on their own plots of land rather than in public cemeteries. When the families died out, these private burial grounds became forgotten, overgrown and basically lost. This particular graveyard was rediscovered in a very grisly, ghastly fashion.

In the 1990s, after very heavy rains, a few kids were sliding down the big sandbank on the property of Geer's Sand and Gravel Company, having a great—if muddy—time. As the children were rolling around and sliding down the bank, they realized, horrified, that they were passing bodies and body parts along the way.

Authorities were summoned to the scene. There was some question as to whether these were Native American burial grounds, so they called in State Archaeologist Nick Bellantoni, from the Natural History Museum, Connecticut. Dr. Bellantoni determined that the remains were not Native American but those of white settlers.

Fortunately, not many of the graves were disturbed during the mud sliding games, and it turned out that the first grave to be exhumed had huge fieldstones piled on top of it. Under these layers of fieldstones was a coffin lid, still in fair condition, with the initials "J. B." and a date (approximately 1815). Further digging uncovered a skeleton whose chest cavity had been deliberately ripped apart. Bones were scattered all over the place, but someone had attempted to recompose the skull in a skull-and-crossbones fashion. At this point, officials recognized that something strange had taken place.

Research established that J. B. died of tuberculosis and had been living with it for a long time before passing away, as evidenced by the depth of scars on his bones. It was also determined that everyone else buried nearby had died very quickly, probably also of tuberculosis. It was assumed that this was another case of attempts to stop "the vampire" from killing subsequent victims. Back in the 1850s in Rhode Island and in Jewett City people exhumed the bodies, searching for the one that "looked like a vampire"—a cadaver that might still have blood in it, for example (remember there was no such thing as embalming then). Once they found the "obvious culprit,"

Route 138—A Cruise Down the Vampire Highway, Jewett City

they removed the heart, lungs and liver and burned the remaining corpse (as opposed to the European method of impaling). Then, they rearranged the bones into that skull-and-crossbones pattern and piled on top of this many fieldstones to make sure the dead would not be able to "walk" and "attack" others. Heavy tombstones did not just serve as markers, but also served as an attempt to anchor the undead to their graves. In addition, they buried the dead with the feet facing the headstone in another attempt to keep the dead where they lay.

Eventually, the investigators verified that this cemetery belonged to a family named Walton. But J.B. was not a member of this family, and his identity is still unknown. His bones were shipped to the Smithsonian for tests, and in addition to tuberculosis, they found that he had a badly healed broken collarbone. This was a sure sign of hunchback, and he likely walked around looking like Quasimodo. Thus, he best fit the "profile" of a vampire in the eyes of the population in those days. J.B.'s bones were eventually reburied (for the third time) in the First Congregational Church cemetery in Griswold, Connecticut. The *Norwich Bulletin* (Norwich, Connecticut) covered the exhumation in the 1850s and the more recent events in the 1990s.

The Jewett City vampires and others like them were cases of tragic misunderstanding, fear and lack of medical knowledge. Citizens in the 1850s didn't understand the diseases that plagued their lives and so attempted to explain or deal with them through the only ways they knew: the superstitious beliefs of the era.

How much have our views today changed from the times when relatives would converge on a family plot in the dead of night, dig up and burn a loved one buried just days or weeks earlier? You just might be surprised at how much remains the same in postmortem practices.

Harvest Restaurant, Pomfret

My first visit to the Harvest Restaurant occurred virtually without incident. Betty Cordellos and I met with Sandy, a general manager, who walked us through the gorgeous centuries-old dwelling. She pointed out the original beams and sections of the home that had been added on at various times. The time of day was late afternoon, and the place had a very light feeling to it. I used this visit to research property history and the history of its former occupants.

Built in 1765, Mr. Lemuel Grosvenor, along with his wife Eunice Putnam Avery Grosvenor, was the original owner of the house. On January 1, 1795, one portion of the homestead (what is now one of the dining porches) became Pomfret's first post office. Mr. Grosvenor, a brigadier general, was also the original postmaster, appointed to that position by General George Washington himself. He served this post dutifully for over forty years. In addition, the structure served as the rendezvous spot for enlisting a regiment for the Battle at Bunker Hill. Ironically, it was at that battle that Lemuel's father-in-law, Israel Putnam, would become famous by uttering the line: "Don't shoot till you see the whites of their eyes!"

Up until eleven years ago the building served as a residence. Now, it is home to the Harvest Restaurant and serves three meals a day. Sharon and her husband Peter Cooper, a former chef at the Brown University faculty club in Providence, Rhode Island, purchased the Lemuel Grosvenor House in 1996 from the Dean family who had owned and lived in it for more than twenty years.

My second trip to the restaurant proved to be somewhat more active. We interviewed the former manager Ted Reynolds, former head waitress Debbie and Sharon regarding their experiences. Ted Reynolds's office was located at the very top level of the building with Sharon's situated directly

The Harvest Restaurant Sign.

below it. No one would go into Ted's office when he was not there, and it was always kept locked. Monday and Tuesday were Ted's days off but it was usually on those days that Sharon would hear the distinct sound of heavy footsteps, as well as noises and movement, coming from the office above. On many occasions, just to be sure, Sharon would climb the back staircase to Ted's office only to find no one there and nothing amiss. Sharon said someone once mentioned that something tragic had happened in the attic—now Ted's office—which was used as a playroom for the Dean family children, but no one has been forthcoming with any details regarding what that something might have been.

Sharon has heard her own name and the names of others called when she was alone in the building. Of the approximate thirty waitstaff and eight administrative workers, just about everyone reports a similar experience. There have been numerous times when many people witnessed the same thing at the same time. Ted and Sharon are the two people who are almost always in the building and thus are the most exposed to strange events. One waitress in particular, Debbie, however, seemed to be the epicenter of activity while working at the Harvest. She experienced more paranormal occurrences than all of the others combined. Not surprisingly, Debbie has had a strong sense of her psychic abilities since her childhood years and maintains an open attitude towards the paranormal in general. She is the one who experienced the majority of activity in the restaurant.

One event that stands out happened when a group of Indian people entered the restaurant one evening, blessing the doorway as they walked in. In fact, they blessed everything. They blessed the chairs, the table, the menus, the utensils, their food, etc. They lingered at the table for hours, well

beyond dinner and even until all other patrons had left. The usual lightness of the atmosphere began to change, and the building began to feel different to Debbie. "It's one of those feelings not easily explained—it just seemed to change," she said. It felt "very heavy, thick and had almost an electric quality." At that point the hair on the back of her neck stood up, and she heard a low, angry voice whisper, "GET OUT!" The foreign group must have heard it as well because at that moment they all stopped talking and looked at Debbie. Startled, she asked, "Did you say something?" Everyone answered no and without another word, the group "literally got up and ran out of the building!"

Ted then told us about an evening when he and a co-worker had done their usual walkthrough of the back kitchen area to check and make sure everything was off and in order for the next day. Remembering something he had to do in the basement, Ted and the other fellow headed down to the cellar by way of the kitchen. Upon returning they found the hot water faucet running at full blast. After their initial shock, they shut it off and "got outta there lickedy split!" Sharon's mother came in one morning to witness the very same thing, although no one else was there and she couldn't imagine that the faucet had been left on overnight.

A dishwasher was in the kitchen, and an entire rack of freshly washed glasses was lifted up, turned over and tossed to the floor, with not a single glass breaking.

Ted, like others, has experienced "psychic cold spots" and what he describes as "a creepy feel about the place at certain times, as though [like Debbie said] the air or atmosphere has briefly changed." There were times when he was working alone in his office at night and heard what he thought were people, either patrons or other workers, come into the building (even though he knew the main door was locked). He got up to check, only to find no one there. He often found himself standing there and shaking his head thinking "I know I'm NOT crazy! I know I heard that door open and I know I heard people talking! What the heck is going on?"

On one occasion Debbie and Ted were working together in Sharon's office, each on different computers, when something called out Debbie's name in a low, angry masculine voice. Both of them looked up and then at each other. There was no one else in the room. Debbie eyed Ted with a quizzical look, and he replied, "Don't look at *me*! I didn't say it!"

Another occasion of name-calling happened when Ted was bartending and there was only one customer at the end of the bar. Ted couldn't recall her name, but again "someone called out the woman's name" and she looked over at Ted who had also heard it. With wide eyes, he once again declared, "I didn't say that!"

Framed pictures fall from the walls without any natural explanation. Ted told us that he didn't feel that whatever was sharing space with the living here at the Harvest was harmful, but he was unsure as to what or who it was or what their purposes were for being there. "It's just a sense of knowing that 'something' or 'someone' else is here with you when you're alone that can make one feel very on edge."

Sharon recounted how Mrs. Dean came back one day to have a look at what the new owners had done with the place. After showing her the improvements and refurbishments that had been made, Sharon was ready to ask the former owner some questions of her own. Twice she asked her point blank if she knew the house was haunted, and twice the woman avoided answering her question. Sharon also said that people have come into the restaurant and claimed that they had experiences there but "didn't like or want to talk about them."

One woman recounted a story from the time the Deans lived in the house. She had come to pay a friendly visit to Mrs. Dean. She had first gone around back as was her usual custom when calling on the family. After repeated knocking, she made her way back around to the front door and peeked inside the glass windowpanes. She saw the rocking chair rock and then something undiscernable in shape got up and moved away as the chair continued to rock. She later discovered no one had been home at the time.

While alone upstairs, I received the impression that more than one spirit inhabits the building. There is definitely an older male in his seventies who believes that he still owns, runs and lives in the building. It could be that this is Mr. Grosvenor's spirit, staying with the dwelling partly because of his connection with the former post office where he took his position very seriously.

I also sensed a woman connected with the building and received very strong impressions of her in the upper rooms, but I don't think she is of the same time period as the man and she is definitely younger, maybe in her forties. She appeared at the end of the hallway, wearing a gray dress with a high lace collar. My sense of her spirit was one of boredom or sadness and I definitely felt pulled down when I was in her domain (the upper area of the building).

I also feel that there is a younger spirit there, perhaps a teenage boy. Or at least it is an immature spirit of a juvenile mentality. I believe he is the one that does the mischievous things like playing with lights, outlets and the incidents with the water faucets. I do, however, get a sense that he and the older man's ghost have some sort of kinship. I'd even go as far as to say that they are on friendly terms with each other as spirits in the dwelling.

Harvest Restaurant, Pomfret

On September 5, 2001, the following letter was forwarded to me from the Haunted Connecticut Tour owner, Betty Cordellos. She had received it from Sharon, the restaurant owner following my visit:

Hi Betty,

Mrs. Dean herself was here and told me a few of her encounters. She told me of many occasions when she has actually seen an older man and a woman in the house that aren't "of this world."

Once, she was waiting in the front dining room for the bus to come, with her collie sitting beside her, and she felt a presence. She looked towards the alcove and there was a man standing there. He had on a red military style jacket. The dog started to fuss and she looked at her and all of the hair on her back was standing straight up. She looked back and the phantom was gone. That was the only sighting she'd had of him, but others had mentioned to her stories of the same nature. She did say that her dog would never go back into that room.

The other sighting she had was of a woman. Mrs. Dean was upstairs in what's now my office, and was heading for the stairs and there was a woman standing at the head of the stairs. She said she was slender with a very pretty face and she was in a long gray dress. She turned towards Mrs. Dean and was gone.

She also mentioned a time when her daughter Claudia was young they were all sleeping and Claudia started yelling "mommy." Mrs. Dean entered the room and the youngster told her mother to make the girls stop playing with her dolls. Of course Mrs. Dean asked her what she was talking about and she said, "They're right there playing with my dolls." Mrs. Dean didn't see them though and humoring the child ordered the "imaginary playmates" to "stop at once!" Her daughter smiled and thanked her for "making them go away!" She also mentioned hearing noises upstairs just like I hear on occasion.

Donna's correlations, which she stated to us well before any of Mrs. Dean's experiences coming to light, were amazingly accurate!

Sincerely,

Sharon

The Harvest Restaurant changed hands in June of 2007. The new owner is Tony Malis who has only heard the rumors of the ghostly inhabitants of his new place. I'll be checking back in with them come October.

Donna Kent.

About the Author

Donna Kent is the founder of the Cosmic Society of Paranormal Investigation and Cosmicsociety.com, the internet's largest, free, spirit energy photo website. She has appeared on countless TV shows including Sci-Fi's *Sightings* and *Ghost Hunters*, the *Maury Povich Show*, and the ABC Special, *World's Scariest Ghosts—Caught on Tape*. She has authored and published the *Investigating a Haunted Location Handbook* and has written for magazines including *Llewellyn's New World*, *Fate* and the *Door Opener*. She is the editor and publisher of Cosmic Connections newsletter and the 1997, 1998 and Millennium Ghost Calendars. She is also featured in the 2007 *Cambridge Who's Who of Executives and Professionals*. Donna is the director of Haunted Connecticut Tours in the USA, voted Connecticut's number one tour (www.conneCTionsgrouptours.com, Telephone: 203-656-0207). Cosmic Society offers worldwide membership, classes, workshops, seminars and presentations on spirit photography and paranormal investigation. Donna can be reached at 203-732-7772 or CosmicSociety@sbcglobal.net. Please visit her on the web at www.CosmicSociety.com.

Endnotes

The Whitehall Mansion, Mystic
[1] *Whitehall and its Restoration*. Stonington Historical Society, 1970. Used with permission.
[2] An instrument used to measure electromagnetic fields and frequencies, also called an EMF meter.

The White House Inn at Vernon Stiles Restaurant, Thompson
[3] Jane Vercelli (President, Thompson Historical Society), *History of the White Horse Inn at Vernon Stiles on Historic Thompson Hill Common Thompson* (Connecticut: October 4, 1977).
[4] *Ibid.*

The Bloody Orchard, Franklin
[5] Transcribed. (Hartford: F.A. Brown, 1852)

The Lighthouse Inn, New London
[6] *History of Lighthouse Inn*. Pamphlet provided by Lighthouse Inn.

Eugene O'Neill's Monte Cristo Cottage, New London
[7] Excerpt from a letter by O'Neill seeking admission to George Pierce Baker's playwriting class at Harvard for the spring semester, 1914. http://www.eoneill.com/library/review/28/28i.htm.
[8] Eugene O'Neill, instructions to his wife quoted by biographer Louis Shaeffer, cited by Warren Allen Smith in *Who's Who in Hell*.
[9] http://aeofberkeley.org/longdaysjourney.html.

Please visit us at

www.historypress.net